LONG ISLAND ODDITIES

CURIOUS LOCALES, Unusual Occurrences AND UNLIKELY URBAN Adventures

JOHN LEITA & LAURA LEITA

THE
History
PRESS

Published by The History Press
Charleston, SC 29403
www.historypress.net

Images are courtesy of the authors unless otherwise noted.

First published 2013

Manufactured in the United States

ISBN 978.1.60949.920.4

Library of Congress Cataloging-in-Publication Data

Leita, John.
Long Island oddities : curious locales, unusual occurrences and unlikely urban adventures
/ John Leita, Laura Leita.
pages cm
ISBN 978-1-60949-920-4
1. Long Island (N.Y.)--History, Local--Anecdotes. 2. Historic buildings--New York (State)-
-Long Island--Anecdotes. 3. Long Island (N.Y.)--Social life and customs--Anecdotes. 4.
Long Island (N.Y.)--Biography--Anecdotes. 5. Adventure and adventurers--New York
(State)--Long Island--Biography--Anecdotes. 6. Curiosities and wonders--New York (State)--
Long Island. 7. Legends--New York (State)--Long Island. I. Leita, Laura. II. Title.
F127.L8L44 2013
974.7'21--dc23
2013017637

CONTENTS

CONTENTS

CONTENTS

ACKNOWLEDGEMENTS

We would like to dedicate this book to the following people, whose help and inspiration made this possible:

To my mother, Virginia Leita.
To my grandparents John and Virginia Caldwell—I miss you both more than you will ever know.
To Laura's mom, Maureen Cummings, who has always encouraged her writing.
To Leo Polaski, a great historian and friend.

Thank you all. We could not have done it without you.

INTRODUCTIONS

FROM JOHN

It is my pleasure to have you join me on my journey into what makes Long Island different from anyplace else. Every chapter of this book has a personal connection to me. Growing up here, I have seen a lot change, but that just makes it all the more important to hold onto what is left and to enjoy the rich folklore, roadside attractions and historic places that make Long Island different from anywhere else.

I always had a fascination with abandoned places, roadside attractions and folklore on Long Island. It became obvious that there were others who found these things equally interesting, so ten years ago, my wife and I began a blog called "Long Island Oddities." Not only did this allow me to share what I learned, saw and explored with others, but it also gave me valuable feedback about places I wasn't aware of. This book is the culmination of the past ten years of that feedback, tireless research and exploring this island to its fullest.

My first paranormal experience occurred in the first house I ever lived in. When I was three years old, I was sitting on the top floor of an old Bay Shore apartment house near the train station. My mother and her friend were sitting at the kitchen table perpendicular to a window. I looked up at them, and to my utter horror, a face jumped up to the window in between them. It was the face of an old woman sneering at me. I was too horrified to make a sound at first, and by the time I did, she dropped fast. There was nothing under the outside of that window except a three-story drop.

The next apparition I saw was with someone who witnessed it with me. I was still a child when we moved into an apartment building on Keith Lane, in West Islip. The building was once the dairy for Minor C. Keith, a wealthy importer of fruits from Costa Rica. I was sitting on the living room floor with a coloring book. My mother's friend was sitting on the couch. Suddenly, I saw this wavy, clear entity moving toward me. My crayon box levitated and began to move with whatever it was. The wavy thing went through a wall, causing the crayon box to drop to the floor. When I asked my mother's friend if he saw it, too, he seemed quite shaken up, admitting he had. I lived in that apartment for six years and had several other experiences. One time, I even saw what I believe was a UFO. Over the years, I would tell my paranormal stories to others and listen to theirs. I developed a healthy appetite for these stories, and this is what led to my passion for local folklore.

The first abandoned building I remember seeing was the Edgewood State Hospital. I remember gazing into its dark windows from the street and being mesmerized by the thoughts of what mysteries were hidden inside. It was demolished before I got a chance to explore it. Since then, I have explored every interesting abandoned place I've found. This is as close as you can get to going back in time and seeing how things once were.

My grandparents would always take me on road trips as I was growing up. I loved seeing roadside attractions that gave each place a unique flair. As Long Island gets inundated with strip malls and condominiums, roadside attractions become even more important because they allow the area to retain an independent character.

If you enjoy hearing about these places and stories and know of another one, don't be shy. You can contact me at editor@lioddities.com. Happy reading!

FROM LAURA

I can't express how excited and grateful I am to have the chance to put this book together and share all of our experiences and favorite places. It truly is a great honor, and I hope that you enjoy what we have put together for you.

My interest in the paranormal began at the early age of five, when I had my first experience. Late one night, I was awakened to see a woman standing in my doorway. From the way I was lying, I could see her only from the waist down, but she wore a dark blue knit shawl and some sort of calico printed dress that poofed out a bit at the waist. The oddest thing was that

she was also glowing a robin's egg blue. This woman proceeded to walk to the bed and pull the covers up over my shoulders before disappearing. The only thought I remember going through my mind was: "Wait, that's not Mommy." But strangely, I wasn't afraid.

As soon as I was old enough to go to the library, I remember hitting the books hard, my mind full of questions. Though they had children's sections divided by grade and reading level at school, there were a few nice librarians who appreciated my eagerness and let me wander into the forbidden adult section. I read so many stories and amazing accounts in those books. The first ghost picture I ever saw was the Brown Lady of Raynham Hall in England. Little would I know that would come full circle when we found the American location with the same family name and its own haunts many years later.

Since then, I have had many more personal experiences of my own, some frightening, some mysterious and some poignant, but the fire of curiosity still burns bright. My husband and I even shared our first paranormal experience together while we were in college in a dorm building we would later learn had a history of being haunted. Years later, as a result of the "Oddities" blog, we would receive an e-mail from a former student with very similar experiences.

You can't have a strong interest in ghosts without a love of history, and I will always be grateful to have a partner who shares that love. I learned a love of history early on from my mother and grandmother and from visits to new places and museums. I love to try to imagine what it would feel like to live in certain times or to be some of the unique people in our past and deal with the struggles and conflicts that existed. To this day, I am still in awe at the courage and strength of some of our Long Island ancestors, particularly during the American Revolution.

For us, a love for history and ghosts turned into a yearning to explore. I remember when John bought his first digital camera and we walked around the remnants of Kings Park Psych Center taking pictures of buildings and the railroad spur. There was this smell that would waft out from broken windowpanes. It smelled somewhat like books that were kept for years in a basement. It was a musty scent but not unpleasant, and above all it smelled like mystery. It drew us in, and soon I was urging him to do more than photograph the outside. Though our first foray was fraught with fright, and we were nearly ready to leap out of our socks, it was an entry into the brand-new world of urban exploring. Soon, we would share our explorations of other psychiatric hospitals, industrial ruins, old schools and other historic locations. Often it seemed as if everyone had just picked up and left with everything remaining behind.

We had such great adventures in those days! One day, we were down in the tunnels under Kings Park having found a large board just loosely covering an entrance to the old steam tunnels. After hours of wandering around until we were tired, we came back to our boarded entrance. Already dusty, we must have been even more of a sight after dirt rained down on us as we moved the board aside. As we climbed up and finally poked our heads over the edge, we saw a couple standing in complete and utter terror just a few feet away, wide eyes fixed on us. Honestly, it must have looked like a scene from *Day of the Dead*, as we seemed to just come up from the ground. In a weak attempt to ease the situation, my husband dusted himself off and called out, "Be careful, there's a big hole there!" And we left as rapidly as we could.

Our pictures and tales from these explorations seemed to gather more interest than we expected, and in June 2003 we created "Long Island Oddities" together. Here we found a community of likeminded people, and the site thrived beyond our expectations. Soon, we had a little Internet radio station going and later on a public-access TV show called *Odd TV*, which was quite low budget but a lot of fun to make, and it created its own cult following. Later came historic documentaries and other projects.

We are now approaching our tenth anniversary for "Long Island Oddities" this June, something that I still look on in disbelief. Has it really been that long? Time seems to move so quickly. It is fitting that this book, the culmination of much of our hard work, sweat and tears, will be published on or about this time. I hope that it, too, finds its way into the hands of likeminded people. Because of that, I would like to invite any readers to contact us and tell us what you think. Maybe we can share our stories together. There is always more to know, and I would love to hear from all of you. Please feel free to e-mail us at editor@lioddities.com. Thanks for reading. I look forward to hearing from you.

Chapter 1

ROADSIDE ODDITIES

THE BARREL HOUSE

The Hamptons has no shortage of artists, but one made his house a work of art. Located in Watermill is a house that is shaped like a tipped-over barrel. The artist was the late Nova Mihai Popa. Nova was "green" before it was a fad. The house is designed to take up a small footprint on the earth. It is constructed with timbers recycled

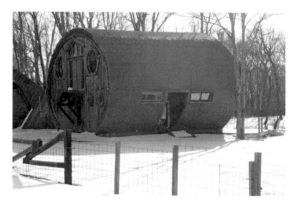

The Barrel House.

from a demolished Brooklyn church. Nova's Ark, as the house is sometimes referred to, was constructed between 1986 and 1991. The Ark property also has a refurbished former potato barn, a petting zoo, art galleries and a sculpture park. Public events are often held there. The house is located at 30 Millstone Road in Watermill.

BIG DUCK

Long Island has been famous for its ducks since 1873, when we had some brought back from China. I am not talking about the mallards that quack in the local lake at the park. These ducks are used for cuisine. Since those first ducks arrived from Peking, many duck farms have flourished on Long Island. During the Great Depression, Martin Maurer bought a duck farm. Like many during the Depression, he had to be creative to make it. To sell his ducks by the roadside and gain people's attention, he decided to build a giant duck with a sales floor inside.

He hired the Collins brothers, who lived in Manorville. Prior to moving out to Long Island, they built props for New York City theaters. They were most talented, especially while imbibing. The brothers studied an actual duck to get an idea for how the building should look. Without blueprints, they constructed a wooden frame. The frame was glued and then further secured with galvanized wire. Masons were then hired to add an exterior wire frame and plaster. The eyes are actually lenses from the taillights of a Ford Model T. The Duck was constructed well enough to survive several moves and the passage of time. Today, it is owned by Suffolk County, which runs a gift shop inside. If you want to see the giant duck, you must travel to Route 24 in Flanders. You can't miss it.

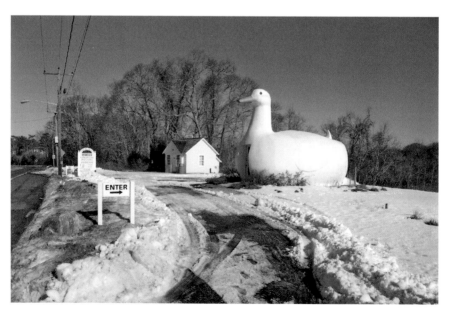

The Big Duck in Flanders.

THE PIRATE HOUSE

Someone told me of a house whose yard is fully adorned with pirate and other nautical decorations. I tracked it down and took pictures. Not long after posting them, I was contacted by the home's owner. Most people would feel uncomfortable about having their house photographed and posted online, but not Dennis Connor. Instead, he invited me over to take more photographs and to tell me the story behind the house's unusual decor. Dennis Connor shook my hand as he joyfully greeted me with: "Welcome to the Pirate House!"

I had many questions for this homeowner, but my first was: "What's the motivation behind this amazing front yard display?" The Pirate House's beginnings are rooted in an extremely tragic event. His thirty-year-old daughter, Janet, was in a car accident while vacationing in Hawaii with Dennis and the rest of her family. The aftermath left Janet with severe mental impairments. During a family trip to Disney World, Janet seemed cheered up while on the Pirates of the Caribbean ride. While driving home

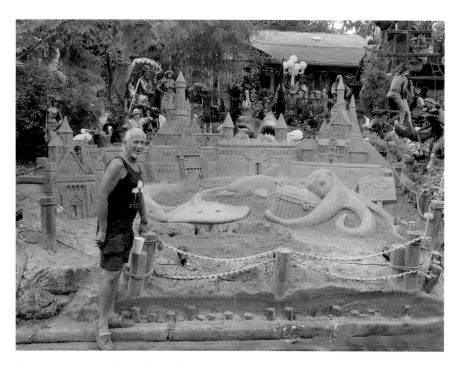

Dennis Connor standing in front of the sandcastle sculpture at his Pirate House. *Courtesy Dennis Connor.*

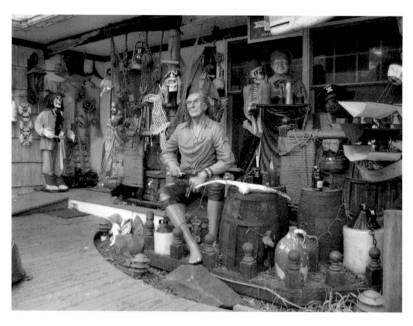

The front of the Pirate House in Miller Place.

in his camper, Dennis came up with the idea to decorate his yard similar to the ride that gave Janet much cheer.

Dennis began purchasing whatever pirate memorabilia he could find. Soon, he was adding anything nautically themed. A giant lobster outside a restaurant, a model of Jaws and the like became fair game for acquisition. When he wasn't purchasing nautical items, he was retrofitting others. A Marilyn Monroe mannequin became Cleopatra on a Roman warship; another of Bruce Lee became an Asian seaman.

Always seeking improvement to his ever-changing landscape, Dennis began hiring local artists to add to his display. One painted murals of an ancient Roman port and a rummy pirate pub. He learned of a sandcastle sculptor who crafted his art for Jones Beach's seventy-fifth-anniversary celebration. The result is a permanent sandcastle on display, front and center, at the Pirate House. Dennis recalls with pride, "He spent one day for the Jones Beach castle but twenty days on mine!"

While some of his neighbors seem begrudged, Dennis doesn't mind visitors at all. "Sometimes people park out front just to look at the yard. I like seeing people enjoy it," explains Dennis. So, if you are passing through or feel like venturing to Miller Place, be sure to check out the Pirate House at 9 Woodland Road.

RIVERHEAD INDIAN

Driving into the Riverhead Raceway for the first time, I couldn't help but notice the giant Native American statue. It acts as a barker vying for the attention of passersby, put in place during an era of competition amongst auto racing venues. Now, the Riverhead Raceway is the last of the Mohicans, so it is only fitting that our native friend stands guard.

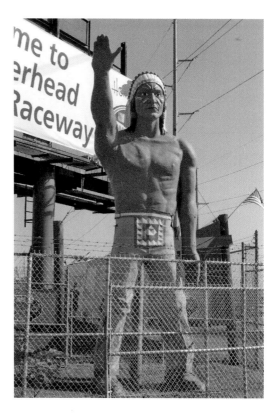

The Riverhead Raceway Indian, originally from the Danbury Fair in Connecticut.

The raceway wasn't the giant Indian's first home. He used to adorn Gold Town at the Danbury Fair in Connecticut. The fair started in the nineteenth century as an annual agricultural festival. During the baby boom years, it was converted into a theme park with different sections. One section was the Dutch Village, molded after New Amsterdam, New York City's name under Dutch rule. Another popular section was the Wild West village known as Gold Town. It featured saloons, gunfights, cowboys and, you guessed it, Indians. Giant statues were scattered throughout the kitschy park, and Gold Town featured giant Indians.

In 1981, the park closed its doors forever. The following year, as amusement park owners, collectors and local residents gathered, the contents of the Danbury Fair were auctioned. One of the attendees that cold, rainy spring day was Barbara Cromarty, co-owner of the Riverhead Raceway. She purchased the Indian and renamed it Chief Running Fair. A Long Island farmer's flatbed moved the chief across the Long Island Sound. The sight gained many looks from people it passed along the way. Occasionally, the

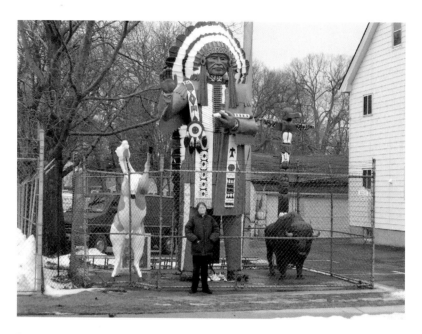

Laura in front of Big Chief Lewis, located alongside Sunrise Highway in Massapequa.

chief would blow over during storms. The Cromartys had it filled with concrete to avoid this.

The raceway is a roadside attraction in and of itself, especially since it is the last on the island. Going there is a trip down memory lane. They still have demolition derbies, which were first promoted at the Islip Speedway. An interesting fact is that the Cromartys owned and lived in the Amityville Horror House, another oddity covered in this book.

Our Riverhead chieftain has competition from another Native American statue. Chief Lewis stands along Sunrise Highway in Massapequa, next to the building bearing his name. It was built in 1968 by Rodman Shutt, a prolific builder of roadside statues. According to local legend, if you make a wish while touching the totem pole, it will come true.

SMITHTOWN BULL

At the corner of Route 25A and Jericho Turnpike in Smithtown sits a full-size statue of a bull. The bull honors the legend of Smithtown's founding.

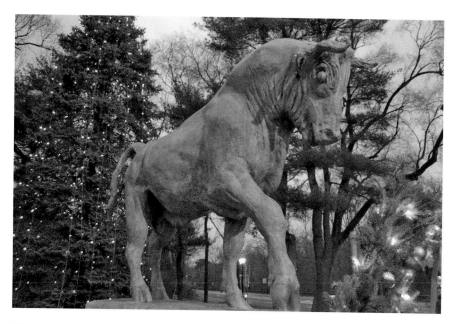

The statue of a bull that sits on Route 25 in Smithtown.

Richard Smythe, like many early English settlers, moved to Long Island from the Massachusetts Bay Colony. Smythe is the old-fashioned spelling of Smith. He originally settled in Southampton, becoming good friends with Lord Lyon Gardiner. The story goes that local Native Americans made a deal with Smythe that gave him as much land as he could encircle with a bull. Smythe prepared Whisper, his own bull, for the journey. Smythe supposedly had made the trip with the bull's favorite cow the day before to offer some incentive. The trip was a success and gave the present-day Smithtown its boundaries.

The story in itself may be bull, but the real story is no less interesting. The Narragansett Indians rowed across the Long Island Sound from Connecticut to attack the unprepared Montauk Indians. Their attack resulted in a massacre of the Montauk tribe and the kidnapping of Sachem Wyandanch's daughter. Sachem Wyandanch was leader of all the tribes on eastern Long Island. He pleaded to his friend Lord Lyon Gardiner to help return his daughter. Gardiner negotiated a ransom that was paid, and the sachem's daughter was returned.

For this act of kindness, Wyandanch gave Gardiner what is today Smithtown. Gardiner later sold the land to his friend Smythe. According to Gardiner family tradition, Smythe won the land in a card game. Either

way, after acquiring the land, Smythe spent the next twelve years in court to become its undisputed owner.

In 1903, Lawrence Smith Butler, a descendant of Richard Smythe, told his family's legend to a classmate. That classmate, Charles Rumsey, happened to be a sculptor. Rumsey crafted a desktop-sized model of Whisper after hearing the story. Upon seeing the model, Lawrence Smith Butler asked his classmate to sculpt a full-size version. Butler began raising the required $12,000 but fell short. First, the statue was on display at the Brooklyn Museum, and then it sat in storage. In 1941, Butler convinced Rumsey's heirs to donate the bull to Smithtown, and it has sat there ever since.

Satan House

For decades, a house in Massapequa has been the center of tall tales and teenage rite-of-passage visits. The house is commonly known as the "Satan House" by many. The owners call it Cafaro Castle, after their family name. Unlike other Long Island houses that have gained their legends from what

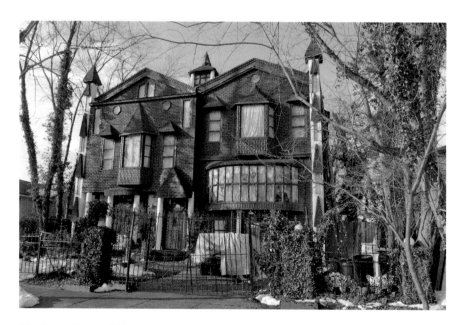

The Satan House of Massapequa.

transpired inside, this house's legends stem solely from its looks. The Satan House is bright red with gothic trimmings and stands out from its neighbors. It is an old house with turrets and an iron fence.

The rumors are numerous, but one of the more common ones is that the curtains are made from coffin liners. Another popular rumor is that the number of candles in the windows represents the amount of people in your car, and seeing them brings misfortune. There's a persistent tale of a horse-drawn hearse in the backyard. The stories, though fun, are nonsense. The family who lives in the house aren't even devil worshipers; they are Catholic.

According to people who have been in the house, the residents are a friendly but eccentric elderly couple. However, there are oddities within. The interior is painted red and black and is extremely cluttered. Even the sidewalk in front of the house is painted red. Someone claiming to be the homeowner e-mailed us to explain, "A red walkway denotes a 'red carpet' to entering guests because the color red denotes purity, joy and celebration. My castle wine cellar contains many red Napa Valley wines."

Our visit didn't lead to us being chased by demons, seeing a specter or witnessing a satanic mass, but we did find an unusual house that was a relief from the boredom of suburbia.

STARGAZER

Each summer, droves of people make their way to the Hamptons for summer fun. Awaiting them is a string of communities containing beaches, nightclubs, seasonal rentals and multimillion-dollar summer homes. The gateway to the Hamptons is marked by a six-story sculpture. It sits there answering the eternal question, "Are we there yet?" The sculpture I am referring to is the *Stargazer*.

The *Stargazer* seen gazing up toward sunset.

Though it is difficult to see at first glance, the *Stargazer* is a deer looking toward the sky with an antler in its mouth. The giant sculpture is seventy by fifty feet and was built in 1996. Though it appears to be made of steel, it is actually stucco. It was constructed to straddle the entranceway of the Animal Rescue Fund in Easthampton. Due to the proximity of an airport, the facility backed out of installing the star-struck doe.

The artist who created the *Stargazer*, Linda Scott, was desperate to find a home for her creation. A local farmer offered up a spot on his farm, and the *Stargazer* has been there ever since.

Stony Brook Hercules

Did you know that Hercules resides in Stony Brook? OK, it isn't the actual Greek demigod. Inside the Hercules Pavilion on Main Street, you will find the wooden bust of Hercules. This was originally the figurehead attached to the USS *Ohio*. The *Ohio* was constructed in 1820 at the Brooklyn Navy Yard. It was

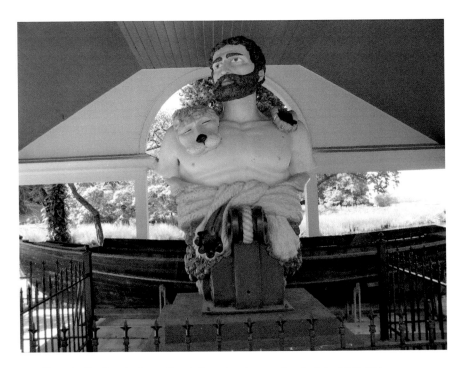

The Hercules Pavilion in Stony Brook featuring the masthead of the USS *Ohio*.

carved from a single piece of wood at a cost of $1,500. The *Ohio* was eventually retired, and the figurehead was auctioned as military surplus. It was eventually purchased by Miles Carpenter, a former owner of the famous Canoe Place Inn. It sat at the inn for decades until Frank Ward Melville purchased it. Melville was founder of the Thom McCann shoe line. He donated land in Stony Brook that became museums and Stony Brook University. The Hercules figurehead was finally bequeathed to the Ward Melville Heritage Organization.

PINE WORLD

While traveling through Westhampton to find Paradise, another site documented in this chapter, I spotted two Spanish cavalier statues dueling in front of a southern European castle. As I walked the grounds, I was pleasantly surprised to find them speckled with vintage sculptures and a fountain baring the words: "Pine World Park." The works appeared to be a cross between old ruins and folk art.

Two dueling cavalier sculptures at the former Pine World Park.

Sculpture at Pine World with the sculptor's castle in the background, now the property of Casa Basso Restaurant.

What I actually stumbled upon was century-old creations of Theophilus Anthony Brouwer Jr., an artist and sculptor. Theophilus was born in New York City in 1864. In 1878, he took a trip to East Hampton to sketch. East Hampton was an artist's mecca, and Theophilus must have liked it because he moved there, opening a repair shop that fixed just about anything. After reading about iridescent pottery made from an ancient practice the Indians acquired from Spanish monks, Theophilus began making pottery.

He married Sarah E. Rogers, who was from the site that would become "Pine World Park." In 1902, he purchased the land from Sarah's father and relocated there. He built a castle molded after one he had seen in Seville, Spain. The miniature castle was constructed with Theophilus's own hands. He then went on to build several other sculptures that were inspired by a trip he had taken to southern Europe to study art. In front of the castle is a rearing horse terrified of a coiled snake. This was a common sight in Spain. Next to the horse is a Roman lion.

Since 1928, the site has been home to Casa Basso, a restaurant that has maintained Theophilus's work. If you would like to see Pine World Park, it is located at 59 Montauk Highway in Westhampton.

YAPHANK GAS STATION

Anyone remember days when "full service" meant an oil check, having your windows washed and your tires checked? Well, passing by the Yaphank Garage on East Main Street, you would think you were still in those times. The station was originally a Shell station that dates back to 1937. Today, it is run by the Suffolk County Police

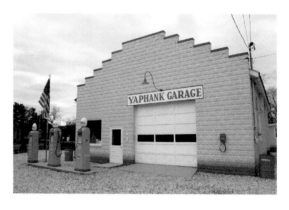

The Yaphank Garage, restored to its vintage appearance.

Museum, which restored it to its original appearance. It has historic police vehicles stored inside and an old tow truck outside. Though it no longer pumps gas or services cars, this is one gas station that is worth a stop.

"MR. MILLENIUM"

The Hamptons always conjure up thoughts of long hot days at the beach and warm summer nights at the bars. A snowman is the last thing one associates with the Hamptons, unless you are familiar with "Mr. Millenium [*sic*]." This snowman stands nearly twenty-five feet tall outside North Sea Auto Radiator & Towing in Southampton. He is complete with a giant top hat, mittens, scarf and two eyes not made of coal. According to his plaque, he was built in 2000, which, along with a spelling error, accounts for his name.

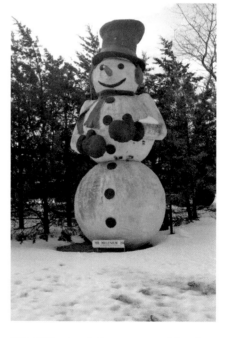

"Mr. Millenium," the snowman of South Hampton.

SPHINX

The promise inscribed under the sphinx reads, "She who climbs the sphinx's head, a millionaire will surely wed." Please don't try because this scaled-down sphinx is close to one hundred years old, but if you have already done so, please let us know if it worked. This comical sphinx is the creation of a comical character, Captain William Graham.

The captain came to the United States from Belfast, Northern Ireland. There he was a sculptor and marble worker. He first settled in Manhattan, becoming a member of the Wyanokes Rowing Club on the Harlem River. That's how he earned the title captain. After marrying, he moved to Bluepoint, Long Island, and opened an inn called the Anchorage. In 1897, the Anchorage was open for business. He began self-publishing a newsletter called *The Log*, a local travel guide featuring his own brand of humor. The Anchorage became quite popular and hosted many famous visitors, including stars Douglas Fairbanks and Mary Pickford. Famous politicians such as Theodore Roosevelt and Charles F. Murphy, the grand sachem of Tammany Hall, also stayed at the Anchorage Inn. Many etched writings into a back wall that doubled as a de facto guest book.

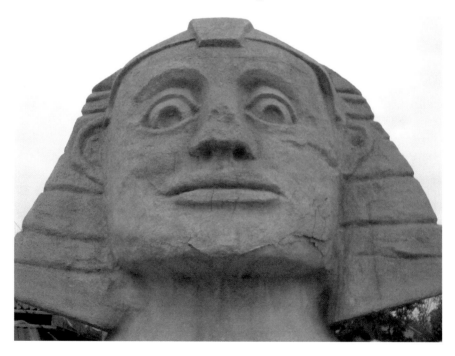

The Great Sphinx of Long Island on Montauk Highway in Bayport.

The captain kept up his sculpturing, and hence the creation of the Great Sphinx of Long Island. It must have helped spread the word of the Anchorage Inn. Captain William Graham passed away in 1920, and the Anchorage Inn was destroyed by fire in 1928. Mae West offered to buy the sphinx, but the sale was never completed. Soon after the fire, the site was sold to Anthony and Helen Ferri, who turned it into the Bluepoint Gas Station. They sold the gas station in 1972 and moved the sphinx down the road to a relative's cement company. Today, the sphinx sits in front of the Fontana and Sons Cement Co. at 890 Montauk Highway in Bayport.

Paradise

Some think of Long Island's sprawling beaches as paradise, but this unusual Speonk beach's nickname is Paradise. It is also called "the Waterhole" by local residents. This beach doesn't sit on the Atlantic or any bay. It is a man-made lake surrounded by pristine sand in the middle of a beautiful pitch-pine forest and consists of pure blue fresh water. This gorgeous lake was not the intention of its creators. In the 1970s, the Mason Mix Company, a sand mining operation, was digging when it hit an aquifer in the bottom of its quarry. The pit quickly filled with pure water so fast that the company left trucks and equipment behind. The Hamptons Dive Center uses the lake for training divers. The land was privately owned for many years, but that didn't stop people from camping out, riding dirt bikes and having fun in the idyllic setting.

Mansion McDonald's

Sprawling cookie-cutter homes called McMansions have been popping up around Long Island. This is the case of role reversal, where a mansion became a McDonald's. In the late 1980s, a large farmhouse was purchased. The intention was to knock it down and build a McDonald's in its place. The problem is that the old home was a New Hyde Park landmark, and the local residents didn't want to see it removed. After all, it had been there since 1875. The home originally belonged to descendants of the area's founders, the Dentons.

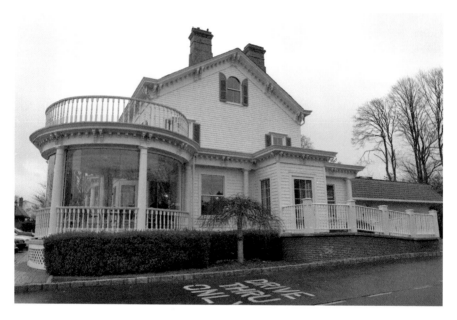

This former New Hyde Park mansion is now a McDonald's.

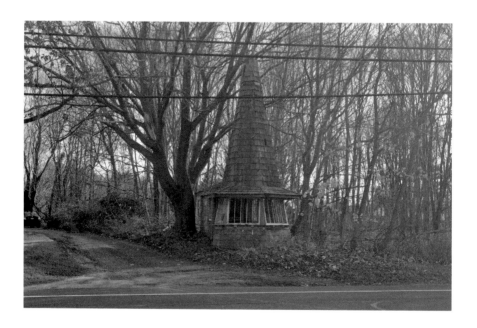

The Witch's Hat on Route 25 on the North Fork.

In 1988, the house was given landmark status, and the plans were temporarily stopped. A compromise was reached so that the house would become a McDonald's while leaving its exterior intact. Actually, this wasn't such a farfetched idea because the house has been utilized as a restaurant since the 1930s. First, it was the Charred Oak Manor, and later it became the home of Dallas Ribs. In 1991, it became McDonald's number 12000. So, the next time you pass through Hillside Avenue in New Hyde Park, have a side of history with your Big Mac.

WITCH'S HAT

Farm stands are no stranger to Long Island's North Fork, but this one in Aquebogue is different from the rest. It looks like a giant witch's hat. It was built in the 1920s as a vegetable stand. Since then, it has been used by many different peddlers, even the Girl Scouts. Though run-down and vacant, this roadside attraction is a North Fork landmark.

Chapter 2

ODDLY ABANDONED

BULOVA WATCHCASE FACTORY

Towns are often built around the industries that flourished within them.
Such is the case with Sag Harbor. It was originally a well-known and thriving
whaling village. But later, as the whaling industry declined, other industries
rose to take its place. The Bulova Watchcase Factory filled that void in 1881
and allowed the town to flourish once more. Surprisingly, the building still
stands prominently in the heart of the village, and as of our last visit, it was
in the process of renovation for future use. It also stands as a reminder of
Sag Harbor's fascinating history.

The factory came to Sag Harbor oddly enough on account of mosquitoes.
Joseph Fahys, a shop owner in Manhattan, was having trouble with insects
and mosquitoes at his New Jersey factory and was looking to relocate it to
a better climate. Fahys employed old pensioners, foreign immigrants and
former whaling men in his factory, giving jobs to those who otherwise would
be hard pressed to find them. The factory was one of the best places to work,
with a recreation room, good benefits and clean workspaces. No expense was
spared on the watchcases themselves. In 1890, $6,000 in gold was melted
down every day, and the floor scraps were valued at approximately $80,000
per year.

During the Depression, Fahys sold the factory to Arde Bulova, who took
over operations. During World War II, the factory shifted gears to making
munitions and timing devices. The nation's first radio commercial in 1926

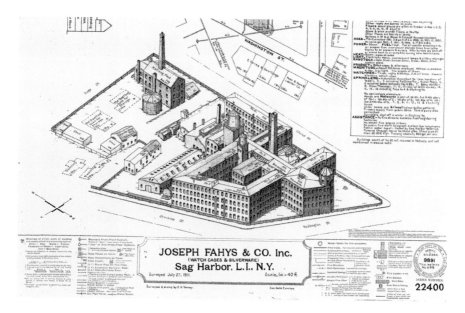

An aerial sketch of the Joseph Fahys Watchcase Factory, which later became the Bulova Watchcase Factory. *Courtesy Oliver Peterson.*

read, "At the tone, it's 8 P.M. B-U-L-O-V-A, Bulova watch time." This wasn't the first of Bulova's clever ideas. Believing in Charles Lindberg's solo transatlantic flight, Bulova produced five thousand Lone Eagle watches with Lindberg's picture in them before Lindberg was even proven successful. The investment paid off—the watches became available the day after Lindberg's return and were a phenomenal success.

While Bulova as a company is still going strong, the watchcase factory closed its doors. The factory produced its last watchcase in 1975, and the building was left to decay over time. And as with all abandoned buildings that tie in with our local history, we took an interest in exploring it.

The old factory looms up as you approach the center of town. Traffic flows past it, oblivious to this relic of older times. It lies so close to the street that we had difficulty finding an entrance, especially with a police station in proximity and police cars streaming past. On the side was a low fence leading to a door. We had no way of knowing if it was open, but it beckoned to us enticingly, and we took the chance. Stepping through that door into a hallway filled with brick dust and peeling paint felt as if we were stepping through time. It was not hard to imagine the sound of machinery and the hallway bustling with people working.

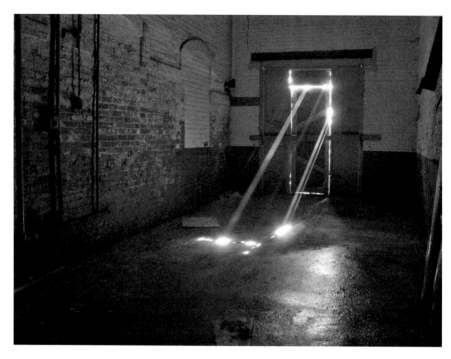

Inside the Bulova Watchcase Factory.

During our wandering, we came across a fire signal system, which to our surprise was embossed with the date 1872. The second-floor bathrooms had collapsed down onto the first floor in one place, and all around nature was trying to reclaim the building through broken windows. On the second floor, a tree was growing halfway into the building, merging into the brick wall in a strange sort of harmony. Light streamed through one locked door, its glowing streaks making a path to the floor. In the center of the building was a courtyard overgrown with weeds and pieces of brick. We wandered hallway after hallway trying to imagine ourselves back in the 1800s while taking our fill of photos and admiring the beauty in decay.

The building has been under renovation for quite some time. Plans to build a condominium complex were started and then halted due to the economic recession in 2000. However, a developer called Cape Advisors has continued the work. Sales of condominium lots will begin next year. The factory lofts will be broken into housing units, and all condos will have gardens, balconies or rooftop terraces. From the renderings, it looks like much of the original façade and features will be saved, including the large water tower on the

roof. It is always a pleasure to see historical structures reused while still retaining as much of the original architecture intact. Perhaps next year we will actually be able to explore what is left of the Bulova Watchcase Factory without hiding in the shadows.

CEDAR POINT LIGHTHOUSE

When you mention lighthouses to anyone who knows anything about Long Island, it usually conjures up images of the Montauk Lighthouse or perhaps the Fire Island Lighthouse. Long Island holds many more of these historic treasures. Though most are restored and open to the public, complete with museums, the Cedar Point Lighthouse is vacant and in a state of disarray.

The lighthouse sits on a point at the northern extremity of East Hampton. It used to be on its own island, called Cedar Island, but the hurricane of 1938 made it into a point. The original lighthouse was built in 1839. The current one was completed in 1868, as evidenced by the stone inscription

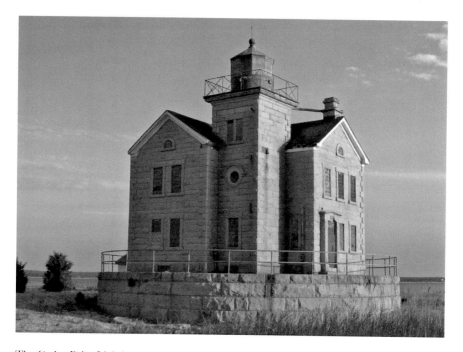

The Cedar Point Lighthouse at sunset.

over the door. It was decommissioned in 1934 and taken over by the county in 1960.

While sealing up the vacant structure, a spark from a welding torch started a fire that left the inside gutted. During a tour inside the lighthouse, I saw a large brick archway on the bottom. This is a cistern once used to collect rainwater for drinking.

Bob Allen's father, uncle and grandfather were all lighthouse keepers and worked at the Cedar Point Lighthouse. Bob's father and uncle passed down a great story of working on the lighthouse in the Roaring Twenties. One day while sitting outside the keeper's house, they witnessed splashing from the rock jetty that surrounded the island. They rowed out to it and found a wounded man. He was shot through the calf. They offered to take him to Sag Harbor, but he refused. He didn't want to go because he was a rumrunner who had been shot by the Coast Guard. They nursed him back to health, and in three days they rowed him to Sag Harbor. A few days later, they heard a loud noise that sounded like "a cross between an off key opera singer and a train horn," according to Bob's father. They found a vessel that looked like an ark. They rowed to the vessel and found the man they had helped. He lowered them a barrel of provisions that included biscuits for their dog, Brownie.

It should be noted that the tales from this lighthouse don't end here. See the "Ghosts Among Us" chapter to hear more.

Sanitariums

Tuberculosis was a horrible disease that didn't spare Long Island. Not surprisingly, both Nassau and Suffolk Counties had sanitariums to deal with those sickened by the disease. The treatment was rest and exposure to fresh air. Though the disease is curable today, it left a scar on Long Island in the form of ruins of the places where people sought treatment.

The Nassau Sanitarium, located in Old Bethpage, was opened in the early 1930s. It remained open until the mid-1960s. Many consider the word "sanitarium" to denote a facility that treats mental illness and maintain that the word "sanatorium" should be used otherwise. The words are actually synonyms. Old maps, records and newspapers call the facility a "sanitarium," but it had nothing to do with the treatment of mental illness. In fact, the mental health facilities all had their own buildings for the quarantining and treating of TB patients.

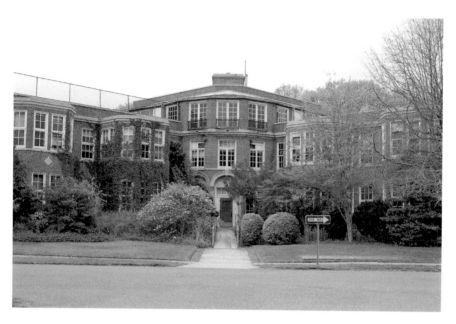

The former Nassau County Sanitarium.

The facility was still practicing segregation until 1961. Richard Thornville was a member of the Peace Corps. While serving in Ghana, he contracted tuberculosis. He was placed in the Nassau Sanitarium and noted that roommates were doled out along racial lines. He wrote a letter to the NAACP, and as a result the county stopped segregating. The superintendent of the facility claimed that the patients wanted to be placed with people of their own race and that it was just "an attempt to make the patients as comfortable as possible."

After its use as a TB sanitarium, the site was used by the county for drug treatment programs and its office of veterans' affairs. Currently, it sits vacant and is owned by Charles Wang, founder of Computer Associates and the Islanders. Considering his dabbling in development, this site may have a shelf life.

In 1913, a TB sanitarium opened in Medford. This facility was built by the Brooklyn Central Labor Union. It was to serve workingmen and their families suffering the beginning stages of the disease. Eventually, it was used as a treatment hospital for TB-stricken children. Today, its ruins sit in the woods alongside Route 112. All that is left are the foundation and basements.

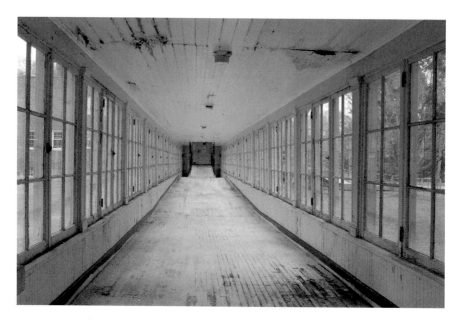

A long corridor connecting buildings at Nassau Sanitarium.

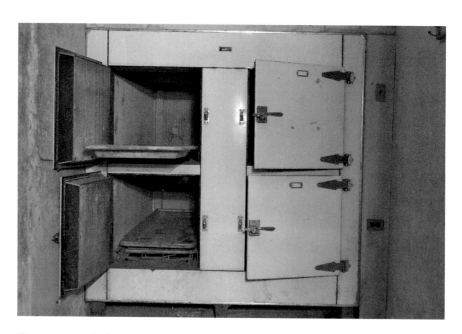

The morgue at the Nassau Sanitarium.

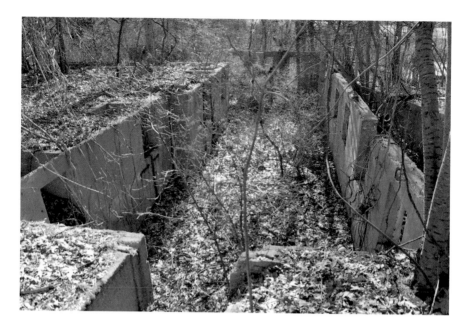

The foundation of the Medford Tuberculosis Sanitarium.

Suffolk Community College's Selden Campus was once a sanitarium from 1916 to 1961. Some of the original buildings still stand, being used as classrooms and offices. Kreiling Hall was once known as Marshall Hall while the center was still a sanitarium. The building's name comes from Dr. J.H. Marshall, president of the sanitarium's board of managers. It was built during the Great Depression as a WPA project. The building housed children suffering from TB. Many believe the basement contains a morgue. There is a walk-in refrigerator in the basement, but it was used for the sanitarium's food services. At the ends of the buildings' wings are large porches. This was no doubt so the patients could be outdoors as part of their treatment. The sanitarium's Ross Hall is now called Ammerman Hall. It was used to house the male patients. The NFL building was once the "new infirmary," replacing one that was much older.

REPUBLIC AIRCRAFT FACTORY

The Fairchild Cooperation was founded on Long Island in the 1920s by Sherman Mills Fairchild. It manufactured planes and equipment used for aerial photography. In 1928, the company built factories and an airfield

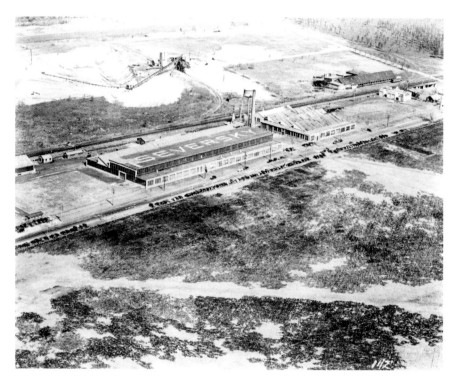

An aerial view of the Republic Aircraft Factory back when it was Seversky. *Courtesy Leo Polaski.*

known as Fairchild Flying Field. The Fairchild Cooperation moved to Maryland in 1932.

The Seversky Aircraft Company, founded by Alexander de Seversky, took over the factory and airfield in 1935. Alexander de Seversky was a World War I Russian ace pilot and lost his leg after being shot down. He was in the United States by the end of the Russian Revolution and decided to remain. The company manufactured the P-35, an early fighter plane. The facility also produced amphibious aircraft. In 1939, the company suffered from financial problems, and Alexander de Seversky was forced out. The company soon changed its name to Republic. During World War II, Republic had twenty-five thousand employees and was manufacturing the P-47 Thunderbolt, the most famous fighter plane used in the war. Republic went on to produce fighter planes such as the F-84, used in the Korean War, and the F-105, which was used extensively in the Vietnam War.

Fairchild Hiller purchased Republic in 1957, and once again the airfield and factories were owned by Fairchild. The F-105 was the last aircraft

designed by Republic before it was made a Fairchild Hiller subsidiary. During the early 1970s, it began manufacturing the A-10 Thunderbolt II, using Republic's naming scheme. Fairchild stopped manufacturing aircraft at the facility, leaving many of the hangers and factories abandoned.

I remember driving through Republic on Conklin Street from the 1980s to mid-'90s. It appeared like it was bombed in a war. Broken windows and buildings damaged by fire and the elements were on both sides of the road. The runway is still used as Long Island Republic Airport, frequented by small craft, private jets and charters. One of the old factory buildings now houses the American Airpower Museum, which features some of the planes built at Republic. The museum is under constant threat, as there is an effort to lengthen a runway that would require its demolition.

Most of the abandoned factories have been demolished to make way for a movie theater and shopping center, but one still remains. I accessed it through a stairway off Route 110 that was once used to reach the Republic stop on the Long Island Rail Road. The gate at the top of the stairs was open. Once inside, I could see the shelter used for the massive amount of employees who once commuted to Republic by rail. Part of the train spur that used to deliver materials could still be seen. I made my way to the large, empty factory and found a window left open. Once inside, I could imagine all the plane parts being assembled by an army of Rosie the Riveters. My grandmother and great-grandmother once worked for Republic and might have been on the very floor where I was now standing.

As I stopped my historical daydreaming, I noticed the entire factory wasn't empty. There were bright poster boards announcing sales and a chain of those red and white plastic flags seen at grand openings. Then I remembered that after the factories were shuttered, this large building was used as a flea market during the 1980s. There was one booth still in place, and it was full of wet, rotted shoes, as the booth's owner left in a hurry. On a pillar, I spotted a small red sticker that said A10-Thunderbolt. The factory has been damaged by a fire since I visited it, and some smaller buildings around it have been demolished over the past few years, so its fate isn't looking too promising.

PATCHOGUE DUCK FARM

One of the main reasons we explore abandoned facilities is to dissect history. Through these explorations, we perform a postmortem of interesting places

The Gallo Duck Farm.

that have helped shape history on a local and sometimes national level. This sometimes leads you to meet people who were connected to the place you are exploring and gives an even bigger history. Our exploration of the abandoned Gallo Duck Farm is a perfect example of this.

We first went to the Gallo Duck Farm in 2003 with some fans of "Long Island Oddities" who had told us about the site. It was a cold winter night. We parked our cars and made our way through an overgrown field. Once through the field, I could see a moonlit collapsing barn making for an eerie scene. We went into a little building that was once a slaughterhouse. There were hooks hanging from the ceiling. The room had two machines, one labeled a "scald machine" and the other a "poultry picker." These were used for removing the feathers from the slaughtered ducks.

A New York merchant, Ed McGrath, spotted large white ducks while traveling in China in 1873. At first, he mistook them for geese but later learned they were palatable ducks. McGrath purchased some eggs and had them hatched. He sent them back to Long Island via James Palmer, of Connecticut. Palmer was promised half the ducks for his troubles. Of the fifteen ducks, nine survived the 120-day journey. Palmer gave three drakes (male ducks) and two ducks to McGrath's brother in New York. Without any instructions, McGrath's brother had the ducks prepared for a meal.

That would have been the end of the story, but Palmer took his ducks to Connecticut for breeding. The ducks took to the environment and thrived, thus seeding an industry. By 1895, the duck industry had spread to Eastport and Speonk on Long Island. A.J. Hallock's farm on the Speonk River was the largest in the world. In one year alone, it raised one million ducks. This farm was completely destroyed by Long Island's most devastating hurricane in 1938.

By the end of World War II, Long Island's duck farms were thriving, perhaps too much so. Competition was fierce, and this hurt the industry. With rapid suburban sprawl, environmental considerations became more important. The refuse from the ducks was a major source of pollution. Costly environmental laws went into effect, further hurting the farmers. Many went out of business between the 1960s and '80s.

The Gazola farm was started by two sons of an Italian immigrant, Louis and Sullivan. Like their father, they were East Harlem construction workers. They wanted to get away from both the city and construction, so they began taking weekend trips to Long Island looking for something else to do. They discovered Long Island's duck farms and thought they could make a go of it, even without experience. The brothers purchased 140 acres of land in Patchogue for roughly forty dollars per acre. The land had a creek running through it, perfect for duck farming. Now all they needed were the necessary buildings. With World War II recently having ended, Camp Upton (now Brookhaven Labs) was selling its barrack buildings. The Gallo brothers bought the buildings at an auction and had them moved to the land they purchased. This was the birth of the Gallo Duck Farm.

Several years after I posted pictures of the abandoned farm to the "Long Island Oddities" blog, I was contacted by filmmaker Marino Amaruso. Marino spent many childhood days working and playing on the Gallo Duck Farm. His aunt Phyllis married one of the Gallos, and the two families were already friends, so Marino was no stranger to the farm. By the time he was around the farm, things were different. No longer was the slaughterhouse used. Instead, the ducks were delivered to a slaughterhouse in the city used by many area farmers. This was probably a result of all the competition during the 1960s causing the farmers to look for ways to streamline things for profitability. Marino has fond memories of the slaughterhouse being used to make tomato sauce. "A truck would deliver a bunch of tomatoes and we would boil and skin them. Then we would use the duck hooks to hang cheesecloth to allow the tomatoes to

drain," he explained as we walked through the slaughterhouse. He went on to tell me that the only time the slaughterhouse was used for poultry in his time was in the autumn, when the family would sell turkeys from a farm stand.

Marino took me inside a small building that was once the farm's office. It had pictures on the walls along with plaques. Marino told me he didn't know who was in the pictures, but he had previously taken any ones he found that had sentimental value. There were piles of paperwork lying all over a desk. The paperwork was mostly related to environmental compliance, the very thing that caused the farm to struggle.

Inside a barn, Marino showed me the incubators. They looked somewhat like refrigerators. The barn is one of the buildings that were part of a previous farm from before the Gallos purchased the land. We were walking toward the back of the barn when Marino, becoming excited, said, "Now this, this is very interesting. When they bought the farm, they left this. This is a hearse from the late 1800s." I found myself looking down at what was unmistakably a cap to a horse-drawn hearse. It was in perfect condition and even had its curtains still in place. Marino said it always just sat there and his family never used it. Marino also remembers the changes caused by the environmental laws. Duck manure was separated from water via a treatment machine. A white powder had to be applied to the water before it was allowed to flow into the creek. They didn't know what the white powder was and used to have fun as kids getting it all over themselves. Sadly, many of Marino's family became ill with cancer and passed away.

Marino's family sold the farm to a developer in 1988. Marino's aunt Phyllis died of cancer a few years later. The developer passed away, and his company became bankrupt. Local government has taken over the property but hasn't done anything with it. It sits there as a ghost of a once successful farm that was part of a former thriving industry.

GREAT GULL ISLAND

Long Island once played a pivotal role in defending the United States. Any naval attack on New York City or New York Harbor would have to pass by us first. The country's response was to build coastal defense barriers at key locations. Great Gull Island sits east of the North Fork,

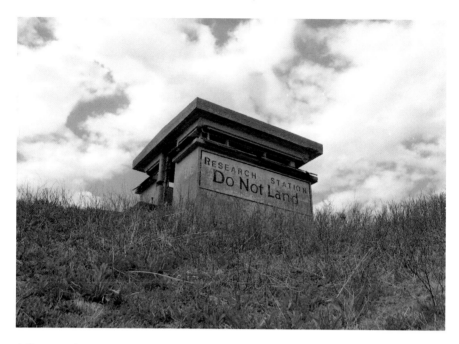

A fire control tower on Great Gull Island that once belonged to Fort Michie. It was once used to spot and locate enemy ships. The Do Not Land sign was painted by the Museum of Natural History.

with Plum Island in between. As such, it played a key role as a first line of defense. Fort Michie was built on this island, and its gun placements were installed for that purpose.

A smidge to the east of Great Gull Island sits Little Gull Island. Since 1809, Little Gull Island has had a lighthouse. Long before Fort Michie was constructed, one of the early lighthouse keepers, Fredrick Chase, utilized Great Gull Island to graze his flock of sheep. With the Spanish-American War looming, Great Gull Island was transformed into a coastal defense fortification in 1896.

Battery Palmer was completed in 1900. It consisted of two twelve-inch disappearing carriage guns. Disappearing carriages recoil and sink after the gun is fired. This keeps the guns out of sight until they are needed and offers them protection behind a wall called a parapet. Under the two guns is a network of passageways that contained the ammunition and supplies to maintain them. Battery Palmer is one of the original placements installed at Fort Michie. Though its guns have been removed, the battery, its network of corridors and the parapet are still in place.

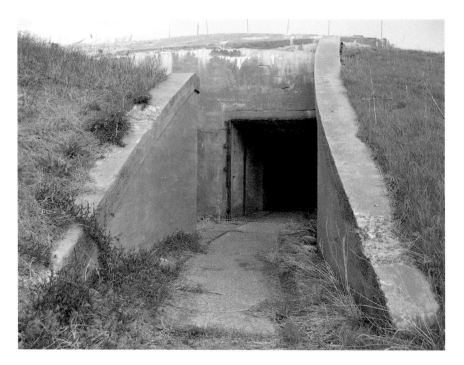

Train tracks going into Battery Davis on Great Gull Island.

Battery Davis, the largest gun of the island, was constructed in 1923. It consisted of one large sixteen-inch disappearing carriage gun. Its battery has train tracks that enter it. This was to facilitate the delivery of ammunition and supplies from a pier. The carriage sat over a large pit that was used for a counterweight to lift the gun over the parapet. During one test firing, the sound from the gun was said to have broken windows in Connecticut. By World War II, the guns were obsolete. Fast enemy torpedo boats and aircraft were now a threat. So in 1943, two concrete pads were installed in front of Battery Davis, and a 90mm gun was placed on each. These guns were rapid firing and could destroy fast boats as well as aircraft.

In 1948, the fort was abandoned. The federal government sold the island to the Museum of Natural History in 1966. The museum has been using it to study migratory terns since then. I first discovered Great Gull Island from an aerial photograph. Noticing a few buildings and structures on this island aroused my interest. Clearly, I had to pay this place a visit. Without possessing a boat or any contacts at the museum, I wasn't sure how to proceed. At the time, my friend, historian Leo Pulaski, had passed away. Leo had authored

books on Long Island's military history, coastal defense fortifications and state hospitals. He was a great resource when I was just starting the "Long Island Oddities" blog, but because of his passing, I thought I would be unable to turn to him this time. While at his memorial service, I ran into some of his colleagues from the Coastal Defense Research Study Group. We began to chat, and they told me they had a trip planned to Fort Michie as guests of the Museum of Natural History. Leo was supposed to attend, and they asked if I would like to go in his place. In a way, Leo was still offering me assistance on my journey.

On my visit, I ran into Helen Hayes, the head of the tern project. She

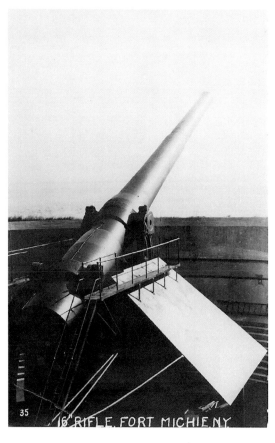

The sixteen-inch gun at Battery Davis on Great Gull Island. The gun is long gone, but the parapet and battery are still in place. *Courtesy of Leo Polaski.*

led us on a tour of Battery Davis's underbelly without flashlights. Each person held the shoulder of the person in front of him or her, while Helen used the walls for navigation. She explained that this would allow us to experience the dark passageways from a unique perspective and gain an appreciation for their vastness. At one point, Helen stopped and told us to turn on our flashlights. There in front of me was the rusted shell of an old Ford that had been left in the tunnel from the military days. We then moved toward a light at the end of the passageway. Before exiting, I passed a large board for hanging tools. Painted stencils in the shape of wrenches marked where each tool was to be placed. One of the wrench stencils was larger than me. Once outside, I was at the pit

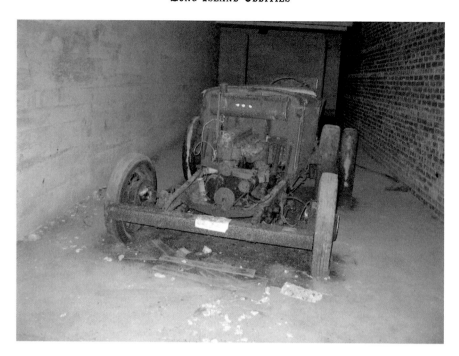

A vintage car that I found inside Battery Davis.

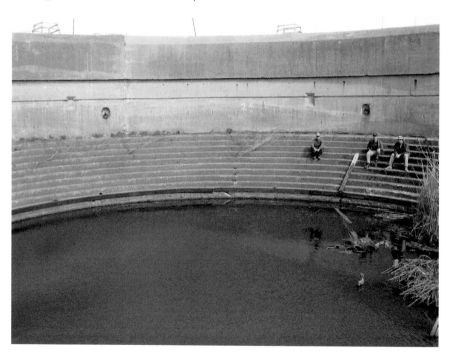

The parapet of Battery Davis at Forth Michie, Great Gull Island.

formerly used to hoist up the sixteen-inch gun. It was immense and quite a sight to behold. I had asked one of the Coastal Defense Study Group members if the fort had ever been used to fight off an enemy. He told me it had not, causing me to reply, "It seems like a waste to build an entire fort that was never utilized." He replied, "You still have locks on your doors even if your house has never been burglarized." He does have a point.

Asylums

Whether seen as a bane to the local community or a welcome haven and refuge for the mentally ill, the psychiatric hospitals on Long Island have made a definite mark on history. Even in their abandonment, they have brought us amazing stories, heated debates on future plans and visible remnants of a history that we don't usually see.

These places captivated me my entire life. Large mental institutions are all over the country, but Long Island's proximity to the New York Metropolitan Area gave us more than our fair share. I grew up in the shadows of the Edgewood State Hospital's buildings. They were long abandoned by the time I came along. Passing the imposing thirteen-story main building always left a strong impression on me. I felt a sense of mystery about how such a large complex could become abandoned. Perhaps it was the buildings' foreboding look as seen from the road, hearing rumors of tunnels from classmates or the need to know what was still inside that made me want to explore every inch of its depths. When I was seventeen years old, I felt a rumble one summer day. The main building had been imploded, and the rest were slated for demolition as well. I never got a chance to roam Edgewood's hallways, and that left a huge impact on me. I vowed that I would be more vigilant in the future when it came to exploring such places.

The largest state facilities for the mentally ill on Long Island were the Kings Park, Pilgrim, Edgewood and Central Islip state hospitals. With the exception of Edgewood, I have explored the hallways and tunnels of each of them. Long after its demolition, I have thoroughly scoured the former grounds of Edgewood and found some interesting things of note.

EDGEWOOD

The Edgewood State Hospital was built in Deer Park in the early 1940s. It was originally intended to be an even larger institution, but the country's entry into World War II put a stop to that and further changed the path of Edgewood's history. Beginning in 1944, all of Edgewood, and part of Pilgrim, was taken over by the military and redubbed Mason General Hospital. They used the buildings to house shell-shock victims returning from war. During this time, a documentary was produced called *Let There Be Light*. It depicted the treatment of shell-shock victims with sodium pentathol and hypnotherapy. In one scene, a paralyzed patient is diagnosed as having psychosomatic symptoms and hypnotized back into walking. It seems a little farfetched at times. For whatever reason, the film was banned by the military but is now available to the public and can even be found on YouTube. The government was also using Edgewood as a POW camp for German officers. A former nurse from Mason General told me of this, confirming something that has always been rumored. She said the officers were treated well and spoke good English.

After the war, Edgewood was turned over to Pilgrim State Hospital. Edgewood was near enough to Pilgrim that this made sense but distant

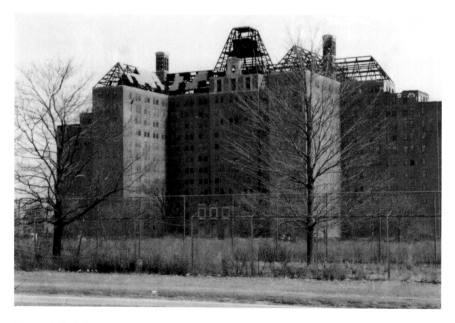

The main building at Edgewood State Hospital after a roof fire that took place in the mid-1980s. *Courtesy of Denis Byrne.*

enough that Pilgrim used it to quarantine tubercular patients. With deinstitutionalization becoming a trend, New York State started shuttering Edgewood in 1969, and by 1971, the task was completed.

Once it was fully abandoned, it wasn't long before trespassers began entering the buildings. They made their marks on the walls with spray paint and left a trail of destruction. In spite of this, many things were left behind to help show what Edgewood was like while it was open. According to one urban adventurer, "It was as if one day no one came back to work. In the offices, calendars were on the walls, desks had papers in them. Some telephones were still there. It was mind boggling to me." The main building had a library, electroshock room and operating rooms. One of the side buildings had a morgue and accompanying lab that still contained specimens. A network of tunnels carried steam pipes from the power plant to all of the buildings.

By the 1980s, Edgewood had become more destroyed, with many of its possessions missing. It became a hangout for teenagers to engage in delinquencies. After Hurricane Gloria, a crew was working behind the main buildings. Several teens threw bricks at them and messed with

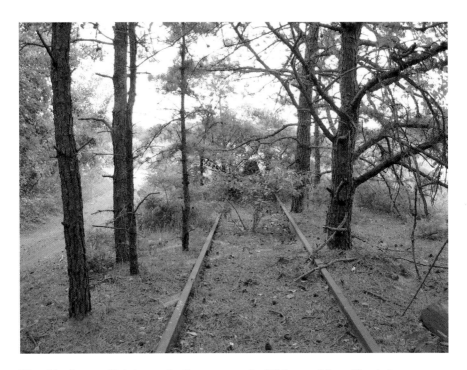

The old rail spur still sitting on the former grounds of Edgewood State Hospital.

their equipment. One of the workmen went in the building after the troublemakers. When he entered a darkened upper-floor room, he was pushed down an elevator shaft. He landed on a plank spread across the shaft by people stealing metal from the shaft. If it weren't for that plank, he would not have survived.

The site became an eyesore to locals and considered a danger to neighborhood teens. The local residents wanted the state to tear down the battered facility. On August 16, 1989, the main building was imploded. Over the ensuing years, the remaining structures were demolished as well. The land Edgewood was on became a preserve and remains undeveloped.

There are still some remnants of the old hospital to be seen. The train tracks that were used to deliver coal to the power plant still remain deep in the woods, and cemented-up steam tunnel hatches can still be seen. In fact, the tunnels still exist under the preserve. You can walk the former grounds of Edgewood after gaining a permit from the New York Department of Environmental Conservation and see these things for yourself.

KINGS PARK PSYCHIATRIC CENTER

One day, while following the abandoned train tracks to the former Kings Park Psychiatric Center, I was amazed to find myself standing in the midst of dozens of vacant brick buildings. One building was looming over all the others with a particularly eerie look. It seemed as if it were beckoning to me. It had hundreds of windows with beautiful stone work toward the top. I peered into one of its broken window and was immediately rushed by a heavy, musty odor. To some, the abandoned building's scent may have been offensive, but to me it was the smell of history and adventure. Inside, I could see a set of murals painted on the walls depicting a caricature of life in that room. There were patients playing checkers and engaged in activities. A nurse in a 1960s-era uniform stood over them. My attention was interrupted by an Office of Mental Health police lady telling me to leave. Though abandoned, the facility was still patrolled by the New York Office of Mental Health. I promptly departed but returned many times, exploring as much of the facility as I could, because I wasn't letting any of it slip between my fingers as Edgewood once did.

In 1885, Kings County, now the Borough of Brooklyn, decided to open an extension to its asylum on Long Island. It felt getting the patients out

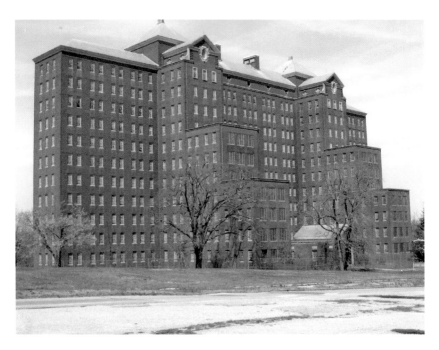

Building 93 at Kings Park State Hospital.

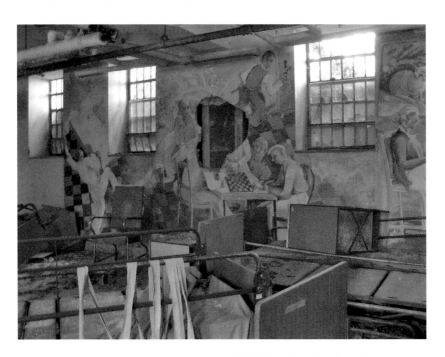

Patient-drawn murals inside the basement of Building 93 at the Kings Park Psychiatric Center.

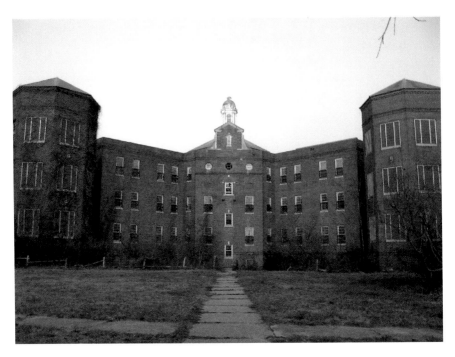

Group #4 consists of three buildings closely connected by corridors on each floor. The buildings on the east and west were for patients. The center building was used for dining halls. Group #4 also has subbasements and a connection to the steam tunnel system. Inside, the layout is confusing and mazelike.

of the overcrowded city and into the country would be conducive to their treatment. It chose an area near an existing orphanage in what is today known as Kings Park. Kings Park owes its very name to the hospital, "Kings" coming from the county that owned the facility and "Park" for the park-like setting of the grounds. In 1896, New York State purchased the facility and took over its management. It went through many name changes and eventually became known as the Kings Park Psychiatric Center. Due to new methods of treatment and current trends in community care, the hospital was closed in 1996.

Unlike Edgewood, the Kings Park Psychiatric Center contained a full array of buildings. It not only has dozens of buildings for treating patients but also recreational facilities, a firehouse, a power plant, staff housing, dining facilities, a warehouse, a bakery, an acute hospital, a laundry building and workshops. The facility had the infrastructure of a small city and, sitting in abandonment, that of a ghost town.

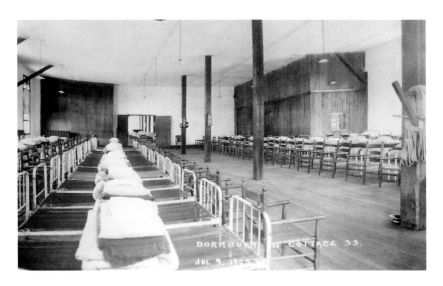

An old patient cottage at the Kings Park State Hospital. *Courtesy of Leo Polaski/Kings Park Heritage Museum.*

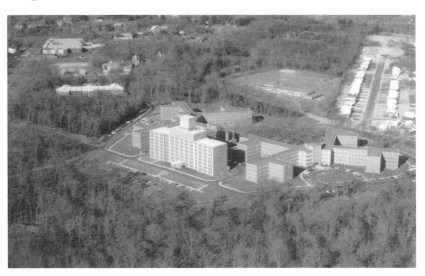

A 1967 aerial view of part of Kings Park Psychiatric Center. *Courtesy of Leo Polaski/Kings Park Heritage Museum.*

In the year 2000, the northern part of the facility became Nissequogue River State Park. In 2006, the rest of the center was added to the state park. The park is quite strange. It looks like the combination of a horror movie setting and a peaceful park.

One of the former nurses' rooms at Kings Park.

On my second sojourn to the site, I found a building with an outside barred stairwell. Under the stairwell was a door consisting only of bars. The bottom bars were torn apart, exposing an entrance. I was nervous and excited at the same time. I was finally going to get the experience I had missed at Edgewood. The door led to a large, empty dayroom. It was cold and damp. The floor had pools of water forcing some of the tiles up. The windows were all barred, making me feel trapped except for my single exit.

The dark gray sky outside added to the drab vibe of my surroundings. I made my way across the room to a hallway. On each side of the hallway were small rooms and offices. Each one was empty, yet I had the strangest feeling that someone was hiding in one of them. Water drops, wind and normal building noises made pops and creeks. One door led to a stairway. As I began climbing, a loud *bang!* on the second floor sent me sprinting to my exit. Each time I entered the buildings after that day, I did so bringing less fear and more curiosity.

On my next trip into that building, I headed for the basement. The ground was flooded about six inches high. I could hear the unmistakable hum of a transformer in the distance. There was still power to the building, though none of the lights were on. I made my way out of that potential hazard and into a room with pipes and a cylindrical tank. In one corner, I found a small metal hatch. It led to the tunnels I've always heard of. The tunnels were used to transport steam to all the buildings from the power plant. When in use, the steam pipes would sometimes crack. Putting them in tunnels made it easier for workmen to make needed repairs. Tunnels always add an interesting element of mystery and surprise to exploring because you

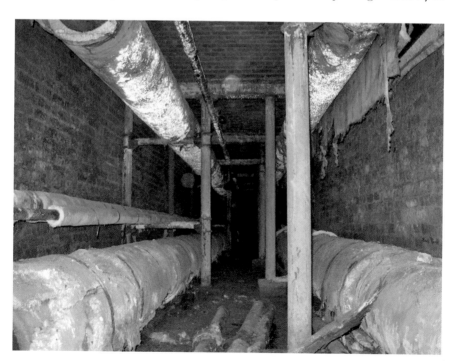

One of the older steam tunnels under the Kings Park Psychiatric Center.

never know what they will lead to. This particular tunnel led to all dead ends because its other entrances were sealed off many years ago. Across from the steam room, where the tunnel entrance is located, there's a stairway that leads to a long corridor with glass windows on both sides. It took me into the kitchen/dining hall building for that group. It was a standard-looking institutional kitchen with walk-in refrigeration, large ovens, huge mixing bowls, a scullery for washing dishes and two serving counters. The dining areas still had tables, chairs and fake plants. Another corridor led to yet another patient building. From that corridor, I was alarmed to hear what sounded like someone moaning in pain. It was just a pigeon.

My main goal was to enter the large brick building with the murals that I had found on my first trip. The police lady who had chased me away that first time warned me of asbestos and former patients and an arsonist who roam its halls. I remained undeterred. I felt the best way in without being detected was the tunnels. Surely, they must lead to such a prominent building. I found a way to the main tunnel off which most of the other tunnels branch.

The power plant was quite impressive. There were three large boilers and a series of catwalks and ladders that led to the top of them. The control room had old computer terminals and bookcases of manuals for the operation of the equipment.

From the basement, I entered the tunnels. A short distance later, I came to a room that had large pipes twisting throughout. There was a stairway leading to a bricked-up doorway. This room was actually once part of an older power plant that had been long demolished. They kept it as a steam junction. I felt like I was inside a phantom building seeing a piece of what was no longer in existence. The tunnel out was flooded and necessitated climbing on the pipes to cross. The site's topography caused the tunnel to change height. I climbed two ladders and entered a spur with a metal door at the end.

I opened the door and found myself in a large sub-basement. On one side, there was a door with a stairway leading outside. I looked through its glass panes and could see I was under Building 93, the very structure that was my objective. The door was welded shut, and there were no staircases leading to the upper levels. I found a room under the bank of elevators, but it was a one-story climb up the shaft to the rest of the buildings. I realized that if I could make it up that one flight, there would be normal stairwells allowing passage to the entire building. I suddenly remembered seeing an old wooden ladder in one corner of the sub-basement. I made use of it to climb the shaft. Peeling back one of the elevator doors led me to the floor with the murals. My breath was taken by the site of murals on each wall. In one section, a bunch of patients were painted

in the act of looming fabric, and sitting in the room was a fabric loom. I then realized I was seeing the room through the eyes of a patient, allowing me to peer back in time while simultaneously seeing the room as it was today with broken up floor tiles, dust, old beds and piles of junk.

Other trips through the tunnels led me to nurses' dorms in serious decay, a hospital building with a morgue and dead-ends that once led to buildings from the nineteenth century that are long gone. The many long days I have spent exploring Kings Park have etched an image into my memory and my soul.

CENTRAL ISLIP STATE HOSPITAL

The Central Islip State Hospital was opened in 1889 and served the needs of New York City residents. It was originally called the New York Farm Colony for the Insane. The original patients were transferred from New York's Hart Island facility. As the decades drew on, the population increased. Central Islip had over one hundred buildings at one time, and its campus was sprawling. In the 1980s, during the height of deinstitutionalization, parts of the campus were abandoned, and others became a campus for the New York Institute of Technology.

The first building I explored was the Corcoran Complex. It has since been torn down to make room for development. This part of the hospital was made of two connected patient buildings with a kitchen/dining hall in the center. The buildings contained wings stretching out in a zigzag pattern. Central Islip amazed me because it had more of its original possessions in place than the other abandoned state hospitals on Long Island. Some of the day halls of these buildings still had all their furniture and clothing. I even found a diary of a patient.

Though there has been a lot of demolition and development, some of the abandoned buildings are still standing. The Sunburst Center is a large string of small buildings all connected by a very long semicircular hallway. These small buildings served as a place to treat and quarantine tubercular patients. For the purpose of isolating the afflicted patients, it was self-sufficient, containing its own kitchen and medical facilities.

The New York Institute of Technology took over these buildings and renovated almost half of them. The renovated half houses its architectural program, the library and an administrative office. The other half was left abandoned. This is what made the building interesting to explore. In the center of the two halves

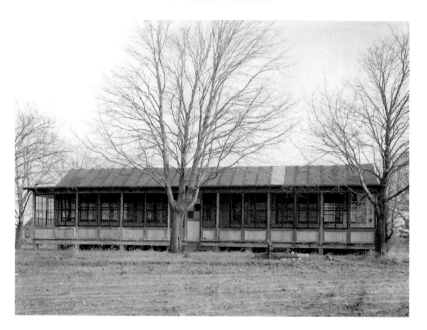

The long-gone tuberculosis quarantine building at Central Islip State Hospital. It was replaced by what is now called the Sunburst Building. *Courtesy of Leo Polaski/Kings Park Heritage Museum.*

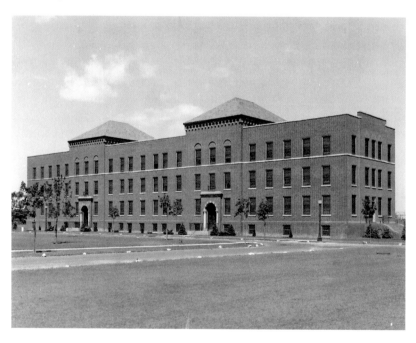

A nurses' building at Central Islip State Hospital. *Courtesy of Leo Polaski/Kings Park Heritage Museum.*

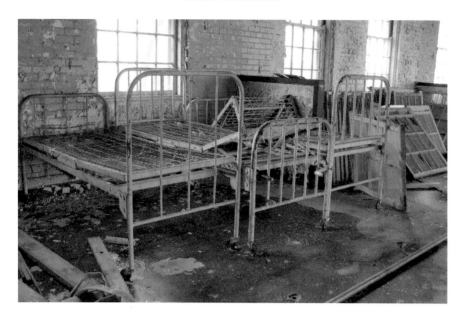

Old beds sitting next to one another in one of Central Islip's tuberculosis quarantine buildings.

was an unlocked door next to an office. While poking around, I went through that door and was immediately immersed in a different environment. Instead of being brightly lit, with students prancing around and a shiny new floor, it was deserted. The old floor tiles cracked under my feet, and it was dark. That musty smell of history was thick in the air. I felt like I had gone through the looking glass. Some of the buildings still had their old iron beds packed close to one another. Each building has a barred-in porch alongside it. The porches were all barred in as if patients might still escape. The porches served the purpose of giving the tubercular patients access to fresh air. This was part of their treatment.

There are other parts of the facility that give this "through the looking glass" feeling. The former James Group consists of several cottages with a kitchen/dining facility in the middle and a former acute medical building. Today, the college uses all but one of the cottages; the other is still vacant. Between the James Group and the Duck's baseball stadium is the admission building. The hospital used it to initially place incoming patients. The admission building is four stories tall and still has barred windows and restraints inside. In its basement, I found a tunnel that led to the James Group. It wasn't a steam tunnel like the ones at Kings Park. It was used for transporting patients around the campus. Under the former medical building, I found a gurney. Again, I felt like I was peering back in time, as the tunnel hadn't been used in decades. The medical building

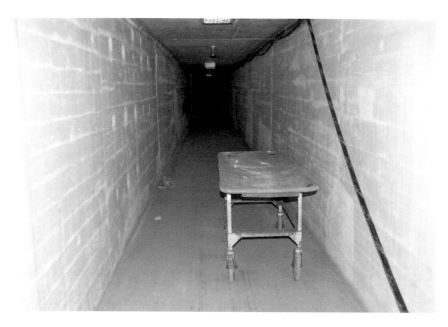

A long-unused gurney sits in a patient tunnel under NYIT, formerly the Central Islip State Hospital.

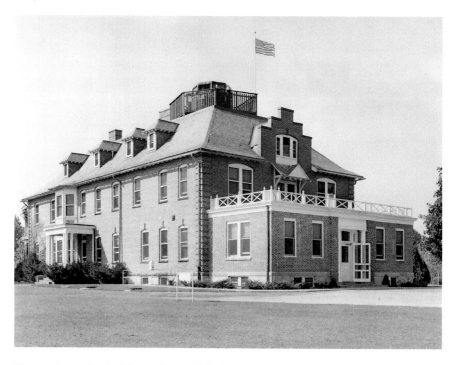

The administration building at Central Islip State Hospital with a World War II aircraft spotting station on its roof. *Courtesy of Leo Polaski/Kings Park Heritage Museum.*

now houses the college security office, so I tiptoed past it. The tunnel forked off a few times, continuing to all the buildings of the James Group. Stenciled signage pointed out where each tunnel went. The campus gave the buildings typical names like Challenger Hall; the stenciling called them by their hospital designations, such as L-3. One of the tunnels led to a closed double door. Light was coming in through the crack in the middle of the doors and illuminating the dark tunnel. Peering through the crack, I could see a student doing her laundry. The college had laundry machines right on the other side of the door. The students didn't even know there was a doorway to a long-abandoned tunnel in that laundry room. Again, I felt I was peering through the looking glass.

The abandoned administration building sits on Carlton Avenue and appears like a brick house. Inside its basement, I found a room filled with old patient records. These were bound in mold-covered volumes. Inside each volume, the patients' lives were extraordinarily documented. Everything from what they had in their pockets when they were admitted to their autopsy reports was detailed in order. Peering through the pages, I saw old, sepia-colored photos of the patients, their dental charts, telegrams sent to them and every other document that makes up a person's life.

Pilgrim State Hospital

Pilgrim State Hospital was opened in 1931 to alleviate overcrowding at Kings Park and Central Islip. At its height, it had a larger population than any other hospital in the world. It still remains open today, but much of the property has been sold to a private developer. Pilgrim's abandoned buildings came with the deal. Just recently, the developer started demolishing many of the structures, but some still exist. Unlike the other hospitals, most of Pilgrim was constructed at the same time. This is why it has a symmetrical, well-organized layout. With its rows of brick buildings, Pilgrim always reminded me of an old factory complex.

Pilgrim was the last of the psychiatric centers I explored on Long Island. I entered the former female admission building through an open window. It was empty, for the most part. I continued through a corridor that connected it to the medical/surgical building. This building, too, was empty, but there were some interesting parts to see. The only thing left behind on the first floor was an X-ray machine, fully intact. I went downstairs and found a row of laboratories that looked like high school biology labs. One wall had a microscope painted on it alongside a rainbow. Inside an adjacent room, I came upon the morgue. The

Old keys in a drawer at the abandoned lock shop inside Pilgrim State Hospital.

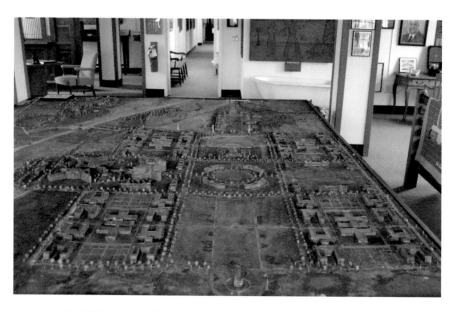

A scale model of Pilgrim State Hospital that was once featured in the 1939 World's Fair.

slab drawers were open, and I could see another room through them. I went back into the hallway to find this other room. It was the autopsy room. In the center of the room was the table where the final examinations were performed. It had holes for drainage throughout and a sink attached. The top floor of the building had the operating rooms. The walls were tiled and suffering water damage because of the leaking roof. This is the very room where an alarming number of lobotomies were performed.

The steam tunnel system under Pilgrim is massive. It consists of two main tunnels that meet at the power plant and dozens of spurs going to most of the buildings. One tunnel stretches under the Sagtikos Parkway to where a group of staff houses and apartments were. Sadly, this group of houses was torn down recently. They were beautiful brick homes with terra cotta roofs. Each one was connected to the tunnels and offered easy access to the maze below. One Valentine's Day, Laura and I walked the tunnel from the doctors' houses under the parkway. We heard the cars passing far above. At the other end, we entered a warehouse-looking building. It contained all the shops used to maintain the hospital. Upstairs, we found the lock shop. It had shop benches and a slew of drawers for keys. One of them was filled with skeleton keys that the employees once used. This building is still standing at the time of this writing, but its future is uncertain. The power plant is still there as well, but much of the equipment was removed and scrapped. The old coal boilers are still in place. There are two rows of three of them, and they are a couple stories tall. The center of them forms a large indoor space that reminds me of a cathedral. Inside one room, I found blueprints for all the buildings and the tunnels.

Though there has been a significant amount of demolition at the three state hospitals, they were so massive that there will always be something left. There are still active buildings at Pilgrim as well, though the number of patients there today is a fraction of how many there were during the peak. The largest buildings at Pilgrim, the 80s group and Building 25, are still utilized. Building 45 contains an impressive museum that houses old pictures, a scale model of Pilgrim, vintage restraints and many other artifacts collected from all of the Long Island state hospitals. It even has a piece of the mural from Building 93 at Kings Park.

Exploring these facilities has always given me a profound sense of adventure, history and respect for the people who lived and worked in their walls. Throughout my explorations and documenting of these hospitals, people always ask me if they were haunted. We have collected numerous stories throughout the years.

Chapter 3

Ghosts Among Us

Haunted Asylums

Throughout history, from the outside, people have often thought of asylums as creepy and possibly haunted. This is not hard to imagine when looking at imposing brick buildings with the knowledge of what they once held within. Many have claimed to hear sobbing and tortured screams in the night. Is it just understandable human superstition, or are the asylums on Long Island really haunted? It may be a bit of both. While the jury may still be out, we have collected quite a few interesting stories from former employees, patients and urban explorers.

In Central Islip, on the NYIT campus that was once Central Islip State Hospital, we have had some very exciting stories, particularly surrounding one building. Building 128 is connected to 127, making up what was called the Corcoran Complex, and surprisingly enough, though they are connected, 128 seems to be the only one housing ghosts. We had our own minor experience even before the stories began to stream in. We opened a door to a ward in our explorations. It was a fairly heavy door, and it did not try to drift closed when we were nearby. But when we returned from one of the bedrooms, we found the door closed. Thinking nothing of it, we continued looking about and returned again later, only to find that same door opened again.

In the very same wing of the building, another urban explorer had a fright. He left one of the bedrooms and heard loud banging and shuffling coming

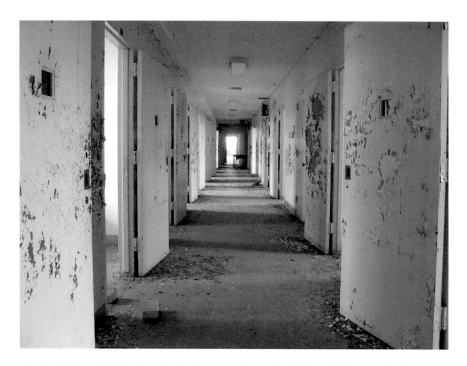

We found this colorful hallway in the Corcoran Complex of Central Islip, not far from where paranormal activity has been reported.

from behind the closed door to the room. Opening it again, he found that the furniture had moved around on its own. Not far from that area, we had another experience with a friend. We came across a door that we had never found open before. It opened into a room where there were film reels and slides. Our friend Tom snapped a picture, and the second it came up on his LCD screen, I knew something was strange. On screen was a strange white swatch, as well as a dark shadowy band seeming to come out of the white blob, which we had not seen with our eyes when the photo was taken. All subsequent pictures came out completely normal, and our attempts to analyze it in Photoshop later still left us completely baffled.

Keeping that white blob in mind, we had yet another adventure in 128. My husband planned a surprise birthday for me inside the building under the guise of a ghost hunting outing. They hung streamers and balloons, and we had cake in the abandoned dining hall. It was an unusual but amazing surprise, but we were yet to be surprised again. Someone said that he heard voices in the hall. We were about to disregard it when a voice from the doorway said, "Actually, your friend is quite astute. He did hear voices." We

turned to see three homeless men, one holding a fireplace poker. After a few initial awkward seconds, both parties realized neither meant the other harm, and we began to talk while sharing cake. They told us a ghost story I will never forget. The men told of a white blob-like object that they affectionately termed "The Bitch." It would phase through walls and shove them out of their beds. Perhaps it was the same white shape captured in our friend's camera. The building has since been demolished, though I wonder whether the ground's new occupants will have experiences of their own.

Kings Park Psychiatric Center, as it was called, has its own share of stories. One of the most common seems to be the entity in white. This is a being that is completely clothed in white, including its skin and face. The eyes are said to ether be black pits or flaming red fiery orbs. It has been sighted near the courtyard to Buildings 21 and 22, as well as in the woods near the asylum. One explorer even spotted the white being inside of the tallest building, number 93. He told us his terrifying tale. He and a few others were walking the hallways of Gothic-style Building 93, rumored to have thirteen stories, though this depends on whether you count the attic and/or both basements. He saw a figure in white coming down the hallway toward him. Both its mouth and eyes were holes in which flames leapt eagerly. He tried to pull out his camera, but it refused to turn on, its batteries suddenly and completely drained. Stunned, he could not move as the thing approached and then passed through him, leaving him dazed, traumatized and nauseous, as if something terrible had come into contact with him.

We had our own strange experience in a group of buildings called "the Quad" by explorers. It is a large multi-building unit with wards and a central dining area located right next to D.S. Shanahan's Bar. During emergency exercises, firemen had broken a hole through one of the cement walls in the basement, revealing hidden corridors and rooms previously unseen by explorers. We found two mural rooms inside with paintings covering floor to ceiling. One of them was an Asian mural room with pagodas, geishas and other Asian-themed artwork. While taking a picture, I noticed a weird shadow in the corner of the photo that I hadn't seen before. I took a few more pictures in sequence and could see the shadow move until it cleared the picture completely. Trying again, I went over to the geisha mural and again noted a shapeless shadow in the first photo only. My second shot came out clean. There was no one else in the room with me and no moving lights of any kind, only my flash. And I would hope we are experienced photographers enough to know not to get our fingers in the way of a shot. We could clearly see a progression of motion on the photos and to this day have not found a suitable explanation.

This is one of a series of photos shot in the Quad's Japanese mural room. Note the strange shadow in the left corner. It is in a different place in each subsequent image.

Others also believe the Wisteria Building to be haunted and claim to have heard sobbing coming from within its walls. Kings Park, like many asylums, is prey to wild rumors of patient abuse and secret torture rooms in the tunnels, rumors that are simply false. But due to that, perhaps, some people claim to have heard screaming in the empty buildings. It is necessary to view some of these stories with a skeptical eye, as it is not hard for imaginations to run amok here.

Pilgrim Psychiatric Hospital is still running, though in a smaller capacity, with much of its buildings demolished or abandoned. Some employees have mentioned hearing footsteps. While exploring the director's house, which has recently been demolished, we had a few interesting experiences. On our first trip there, we climbed through a boarded window in the first floor and wandered into a library with wooden shelves from floor to ceiling. While there, we heard loud and strange banging sounds, as if someone were trying to pry a board off a window, but on the second floor.

Gathering our courage to investigate, we crept up the stairs, thoroughly checking every room and closet on our way, suspecting an intruder. We

reached the third floor and still found no trace of the sound's origin. What was even stranger was that the sound ceased as soon as we began climbing the stairs from the first floor. Satisfied, we made our way back downstairs, and the minute our feet reached the landing, the odd banging sound began again.

But this was not our only experience there; otherwise, I would be quite skeptical. We made a second visit with recorders, EMF meters and cameras in hopes of capturing something. What we captured came as quite a surprise. On the recording, a female voice clearly asks, "Did you miss me, John?" The clip can be found on our website. On a side note, on each visit, the steps going down to the basement drop significantly in temperature, something often associated with the presence of spirits, though in such an old building drafts can happen.

While in no way do I believe every asylum is haunted simply for the fact that it is an asylum, I also have to admit that there have been more than a fair share of stories coming from these locations. I believe that at least certain buildings at each hospital seem to have some activity. With the way these places are rapidly being demolished, perhaps we will never know for sure, but I plan to keep on collecting these stories and wandering these dusty halls.

AMITYVILLE HORROR HOUSE

The horrific murder and haunting in Amityville is probably the most well-known tale around the world, having been publicized in books and movies worldwide. There are so many unanswered questions both in the DeFeo family murder and the haunting story told by the Lutz family. Even today, the house still draws crowds of curious onlookers hoping for a glimpse of something spooky. It is somewhat ironic that the sign out in front of the house once read, "High Hopes."

It all began on November 13, 1974, when Ronald "Butch" DeFeo staggered into the local bar with the gruesome statement that his parents had been shot. His friends went back with him to the house and discovered not only the bodies of Ronnie's parents but also those of his brothers and sisters. After a long investigation and trial concluding just before Thanksgiving, Ronnie DeFeo was found guilty of the terrible murders. But that's where the story begins to get even stranger. There are some who claim it was a mafia hit involving multiple gunmen. Ronnie at some points claimed his eighteen-year-old sister, Dawn, assisted in the killing and even shot her siblings on

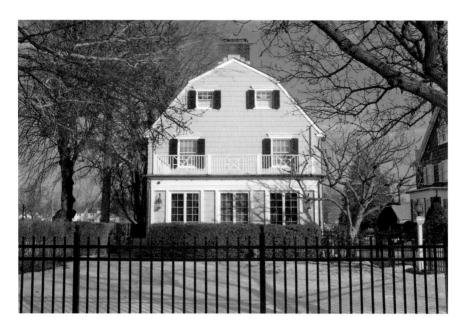

A modern view of the Amityville Horror House. The Dutch windows are gone in an effort to make the house less recognizable to onlookers, but somehow it still stands out.

her own while Ronnie left the house. And even stranger still, initially he claimed that he had been hearing voices urging him to commit the heinous act. There are so many stories, so many questions and so few answers.

About a year later, Kathy and George Lutz purchased the house, hoping for a fresh start for their three children. They weren't fazed by the tale of the house's history, or perhaps it was just that the price was right. However, according to their story, as told in *The Amityville Horror*, they stayed in the house for only twenty-eight hellish days. They first had the house blessed by Father Pecoraro. In the 1980s, he appeared for a one-time video interview on the TV show *In Search Of* with Leonard Nimoy. On the show, he admits that he experienced something strange in the sewing room. A deep voice behind him said, "Get out!" and he was slapped in the face by an unseen hand. When he arrived home, the priest found strange blisters festering on his hands.

This started a chain of events including swarms of flies, strange ooze coming from the toilet and walls, loud noises and windows opening and closing. One of the Lutzes' daughters became enamored with an imaginary friend named Jodie, whose red eyes George Lutz claims he once saw from the window in his daughter's room. Finding a strange red room in the basement,

and unable to reach the priest again, the family decided to bless the house. This only seemed to exacerbate things, and soon it sent them fleeing with just the clothes on their backs.

There are many who say the entire story was a fabrication. Some say it was a story hatched up by the Lutzes and DeFeo's attorney over a few bottles of wine. One member of the Lutz family is still speaking out. Christopher Quarentino, formerly known as Christopher Lutz, is attempting to set the record straight by telling his own story. He has been interviewed on *Coast to Coast*, as well as other radio shows, and tells a very different tale. Chris claims that they did experience a horrifying haunting in the house at 112 Ocean but that it was not from the ghosts of the murdered DeFeos. According to his story, George Lutz was into the occult and was responsible for bringing the haunting on them. He also finds that many of the facts brought forth in the books and movies were inaccurate, such as the breaking of windows.

Whatever you believe in this case, everyone can agree that this one house has put Ocean Avenue prominently on the map of Long Island folklore. No incidents have been reported since the Lutz family moved out, though it is likely that other families would not want the added attention it would cause to report activity. As of our last visit, the house was up for sale again, still leaving folklore hunters with more questions than answers.

THE STONY BROOK COUNTRY HOUSE

Stony Brook is a town full of history, where stately remnants of our colonial past can be found almost anywhere you look, nestled in amongst more modern shops and houses. One of Stony Brook's many still-standing treasures is the Stony Brook Country House, located on North Country Road. The building has been standing for hundreds of years, though serving different uses. Along the way, the Country House may have picked up a few ghostly visitors.

Originally, it was built as a farmhouse for Obediah Davis, and the original structure was added to over time. In the 1800s, the original farmhouse was converted into a stagecoach stop. Later on, it would become the restaurant we know today. While a farmhouse during the Revolutionary War, disaster struck. A young woman named Annette Williamson was alone watching over the property when she was overcome by British soldiers. According to the stories, Annette was hanged upstairs, accused of being a traitor by the

British. She has haunted the property ever since. There is supposedly a family cemetery in the woods in the back of the property. According to Kerriann Brosky in her book *Ghosts of Long Island*, there is a tombstone bearing the name of Annette Williamson.

America's foremost nineteenth-century painter of African American daily life, William Sidney Mount, was known to have séances in the house. He had a deep interest in the paranormal and was known to repeatedly attend similar sittings. Annette is not the only spirit to haunt the restaurant. Across the street is the Stony Brook Carriage Museum. It holds a wealth of early American life exhibits and also a rather unfriendly ghost of its own. According to the owner of the Country House and others, this gruff male spirit occasionally visits the restaurant and is almost never a welcome visitor.

The stories Bob, the owner, can tell would cause hair to stand up on your arm. Annette once threw a chair at his friend, according to Brosky's account, and Bob saw a white shirt disappear around the corner. Some guests have been prone to bursting into tears, and some speak of a strong feeling of sadness permeating the room. One waiter saw a woman walking into the upstairs storage room, but when he raced into the room, no one was there. This apparition also appeared after a large Christmas party. The doorways were hung low with tinsel so that you had to part the strands to enter or exit. The owner saw what he thought was one of the staff in a white tuxedo, but when the tinsel parted, a blue-eyed woman was looking at him.

A location like this one was impossible to resist, so we journeyed out in the cold to experience the ghosts and cuisine of the Country House Restaurant. The restaurant was decorated beautifully in candlelight, and we were led to our own separate room, where we felt like spoiled guests indeed. The room we were seated in had no ceiling, only old rafters through which you could see the second floor above. The room over our heads was the very room where Annette was said to have been hanged, and we had an almost unobstructed view. But the best part of the evening was to be our waiter, Edward. Throughout our dinner, he regaled us with stories of the Country House, both those he had heard and those he experienced himself. It truly brought life to our outing, and we may have even been witness to something ourselves.

On the table were silver reflective platters on which several candles were set so that their glow would shine about the room. Edward told us that at night he saw a shadow moving overhead on the second floor, its reflection cast in the reflective surfaces at our very table. He also had trouble with the candles themselves. Every night, the staff would place out new candles in

preparation for the next day. But in the morning, they would find the candles had burned down halfway overnight.

Bob, the owner of the Country House, and our waiter had both heard their names called when no one was around. The radio, which is located behind a curtained doorway, often changes stations on its own. That curtained doorway happened to be right behind my seat. It did not lead to outside, and yet the curtain would sometimes blow as if a strong wind were behind it. We were not the only guests to have taken notice of that, as Edward told us. Our waiter has also seen streams of light pass by out of the corner of his eye.

The lights flickered, dimming and brightening randomly throughout our meal. Edward told us that electricians had been called in but could find no problem. The stories continued to get stranger as Ed told us about a fellow staff member who was actually injured mysteriously. There is a room upstairs that was rumored to have been slaves' quarters. It has a narrow door with a small window. One of the wait staff went to open the door and received such a bad shock that it turned his arm red all the way to his shoulder. Again, electricians were called in and could offer no explanation, but Ed told us the door has never been opened since. The incident happened six years prior, and the room still remains sealed. Edward had not yet seen her, but Annette is sometimes sighted, especially on the second floor. She wears a white dress, has blond hair and blue eyes and is often seen in silhouette or looking out of a window.

We certainly felt as if Annette's spirit were with us that night as we listened to all of these firsthand accounts and dealt with the wavering curtain and flickering lights. The past, and the Country House's rich history, did not seem so many years away then, and we felt a part of something that will hopefully continue for many years. It was a truly wonderful experience. And while it may be true that the Stony Brook Country House is more known for its ghost than for its cuisine, I think Annette had some pretty tough competition this evening. We do plan to return in the very near future, and we hope that Annette might deign to pay us a visit.

EAST MARION LIFESAVING STATION

Some hauntings can hide in plain sight. You could live next door to a haunted house and never know it. On a quiet street by the water in East Marion sits a unique home that was once a lifesaving station. It may also house the ghost of mariners and coast guardsmen from another time.

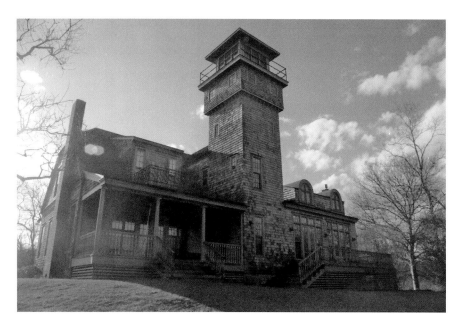

The former East Marion Lifesaving Station, now a private home.

The house was originally a lifesaving station built in 1895, in the early days of the U.S. Coast Guard service. At that time, it was known as the U.S. Life Saving Service. The building was since renovated to be a private home, but you can still see remnants of its past if you know where to look. A tower stands above the second floor of the house with a beautiful panoramic view of the waterfront. The kitchen and dining room used to be the large open area of the lifesaving station itself, and in one place the roof is so high you can see through to the second-floor living room via a panel of windows overlooking the downstairs. Half of the basement is made up of large stones cemented together, an old-fashioned method that confirms the house's age. There is a clear path down to the beach, and it is not hard to imagine men running breeches buoys and life rafts down this very path.

Currently, the owners offer the house up for rent much of the year. It is a beautiful house with many amenities and well worth the asking price if you're renting it as a group. It was lucky for us that we could join a group of our friends who had rented the house for an extended weekend. We were doubly fortunate that the property manager who handed over the keys had a few ghost stories to tell.

She often does regular maintenance and work on the house to keep it ready for new renters. One day, she and another gentleman were downstairs

in two separate rooms of the basement working on wine racks. The man working with her came out of his room white as a sheet and asked her if she had been in this room the entire time because he had heard footsteps. They listened together, and both were now able to hear clear footsteps upstairs. Clinging to each other, they went to investigate but of course found no one.

Hours later, they returned to the basement to do more work, but the property manager felt sick to her stomach and had to leave. That night, she was sick for over four hours, a malady that she attributes to the ghost. There is also someone who comes to cut wood all the time for the fireplace. She told us that he often felt a presence behind him and sometimes heard whispering voices. Last but certainly not least was the story she shared with us about the older lady who rented the house. She was once startled to see the full apparition of a captain in seafaring uniform appear at the foot of her bed. Her bedroom used to be where the second-floor living room is now, directly overlooking what was once the open area of the lifesaving station.

We also had some strange experiences while staying there. We heard the doorknob to the stairwell turn on its own, and it urged us to do some ghost hunting. I pulled out my recorder and wandered about the house. I heard a noise by the stairs going up to the second floor and asked, "Who's there?" To my utter shock, a faint whisper answered me, saying, "I'm here." Though I heard it live at the time, I could not find it on the recording later. The brother of one of our friends reported briefly seeing a little girl at the door when he came in from outside.

The building is cozy, filled with little conveniences, and a wonderful place to stay. Knowing the location's history and hearing the stories told to us by the property manager only enhanced the experience, and we hope someday to be able to return.

HAUNTED LIGHTHOUSES

Even before the colonies won their separation from England, there were lighthouses being erected along shores everywhere, including Long Island. And when in 1789, a new government enacted the Lighthouse Service of the United States, even more towers and lights graced the shoreline's night sky. These towers embody a romantic feeling of loneliness and isolation as we think of lone keepers carrying whale oil and ensuring that these bastions of light and safety for seamen stayed ablaze. It was dangerous

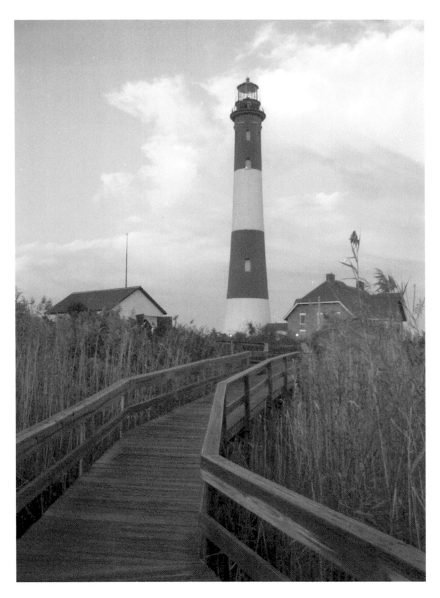

The Fire Island Lighthouse.

work, especially here on Long Island with its storms and treacherous nautical obstacles. A lighthouse keeper and his family had an important job, but one for which they often risked their lives. So it is not unthinkable that our lighthouses may contain the ghosts of the keepers, family and wrecked passengers of yesteryear.

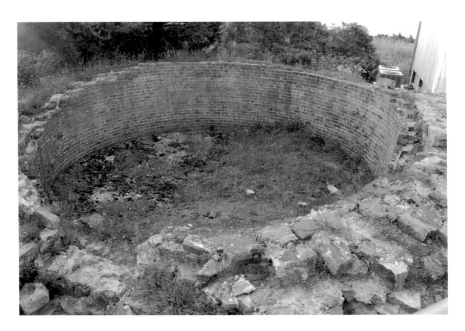

This is all that is left of the old lighthouse from the days of Keeper Smith.

The Fire Island Lighthouse is one of the most visited. It is also one of the most haunted. There was an earlier structure on the site that now remains as only a pile of rubble and foundation next to the new light. It was eventually deemed too short, and a new one was constructed on the site. However, to save on costs, the builders decided to dismantle and use the stones from the keeper's house. The keeper at the time protested, saying the wooden shanty they built for him and his family would not hold them over the cold stormy winters, but his cries fell on deaf administrative ears. Keeper Smith did his best under the conditions, but in the end his youngest daughter caught pneumonia, and her health dwindled. Keeper Smith had to wait three agonizing days for a doctor to arrive, and in the end, it was too late to save his daughter. There is a lesser-known legend of a keeper who supposedly hanged himself from one of the tower windows, but we have been unable to find any concrete proof to date that this occurred.

Some say they hear a man moaning or a child crying near the site of the old keeper's house or down by the shore where Smith waited for the doctor. Inside the lighthouse, the museum interpreters are somewhat reluctant to speak of the hauntings they experience, but we were able to catch some candid responses from a spooked docent on a tour. We were coming down the long winding staircase from the top of the lighthouse, and everyone else had left but us and the docent. She suddenly asked if we would stay with her while she

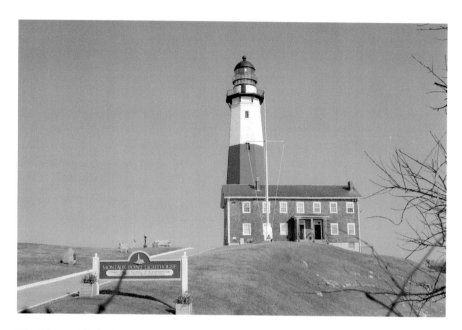

The Montauk Point Lighthouse.

went and closed one of the windows. She told us they always have trouble with the one window flying open, and sometimes she feels uncomfortable being up there alone. One day, she recounted, the electricity was out, and she was very frightened of being in the tower alone as she could hear "weird noises." There are also those who say you can hear phantom footsteps on the staircase.

On the other end of Long Island stands the Montauk Lighthouse, beautiful and majestic as it towers over the waves. It is also a popular attraction for visitors and park-goers out east on the South Fork. It, too, holds a sad tale and a ghost that has never found a way to pass on. You need only ask a tour guide about Abigail and you are likely to get an earful.

Much of the facts in Abigail's back story have not yet been proven, but she is supposed to have been shipwrecked on the shore of Montauk and barely made it to the lighthouse before she died. According to Stephanie Krusa, an author currently writing a book based on the story of Abigail, she was a passenger aboard the sloop *Audrey Lynn*. A terrible storm blew up unexpectedly on Christmas Day 1811 and caught many Long Islanders unaware. Dozens of ships wrecked all over the island. This we can confirm through numerous archived articles, but we have been unable to find a record of this sloop in particular. The story continues that seventeen-year-old Abigail Olsen suddenly found herself strewn amidst the rocks being pelted by freezing rain and icy

kelp. Some say she fought her way free and made it to the lighthouse, and others say the waves took her once more and she drowned. But it is believed that Abigail has never left the lighthouse, even in death.

One gentleman who gave us a tour of the lighthouse told us that some people have seen her apparition in the building. On a previous visit, a woman told us that they have trouble arming the security alarms at night and often have to recheck all of the doors and windows. She felt that there were certain places where she was not wanted and was uneasy entering. Especially at night when closing up, sometimes she could not wait to leave to escape the uncanny feeling of being watched. Aside from not wanting to be there alone after hours, it does not seem that most of the docents fear Abigail. She is as much a part of the lighthouse as the light and will probably remain so.

Lastly, there is a ghost story shared between two lighthouses. Bug Light, as locals call it, is located on the north fork at the entrance to Orient Harbor. It is called that because its appearance is that of a bug crouching on the water. The lighthouse at Cedar Point is located on the south shore between East Hampton and Sag Harbor. What do two lighthouses on opposite shores have in common? They were both manned at different times by the same keeper, and the spirit of the keeper's family dog still visits both locations.

Bob Allen devotes a great part of his life to giving tours of Bug Light and other lighthouses in honor of his grandfather William Follett, who was a lighthouse keeper. While walking along the shore heading to the light, he told us the ghost story of Brownie, the dog that loved lighthouses. William Follett bought Brownie for his family after their pet Mutt passed away. The dog stayed with the family until Follett retired and moved to Greenport, where he died two weeks later. Bob Allen believes Brownie loved lighthouses so much that he just couldn't adjust to being away from them.

Brownie's presence is felt most strongly at Bug Light, where phantom paw print depressions have been seen on the bed in the keeper's quarters. Paranormal investigators placed two dog bones on the floor, marking out their locations with string. When they returned to the room, one of the bones had been moved significantly.

The life of a lighthouse keeper, as well as those who sought their fortunes on the sea, is fraught with danger. Tales passed down of daring rescues, shipwrecks, lives saved and lives lost are some of the most poignant and memorable I have ever heard. And for those who did risk their lives in these occupations, in many cases it was a labor of love and passion. So it is little wonder that even after death there are some who find it difficult to leave what they know and love—the Long Island lighthouses.

ISLIP FIRE DEPARTMENT

Apparently, even a firehouse can be haunted. To my surprise, we began receiving tips about a firehouse in Islip that was haunted by the ghosts of firemen long gone. I admit I was skeptical, but what the men told me made me a believer. We gathered our courage one Friday night and simply walked into the firehouse, passing the trucks and emergency gear without seeing a soul. We made it all the way upstairs to the recreation area before we were stopped, and the guys agreed to tell us their stories on camera.

The firehouse is over one hundred years old, and the recreation area is full of shelves bearing framed pictures of former firemen. Men have seen old-timers standing by the corner of the bar as if waiting to have a drink. One time, the firehouse caught on fire, and as they were approaching it, the door to the top of the stairs opened by itself.

While preparing for a meeting, one fireman set up rows and rows of chairs in the meeting room. He stepped away for just a few moments, and when he returned, he found that every chair on the right side had been shifted over toward the wall. It was set up just as he left it without a chair out of place, except that the whole ensemble was now against the wall.

Lights on the fire trucks mysteriously turn on. Sometimes the TV turns on by itself. One of the men we were interviewing said that he used to stay overnight but never felt that he was alone. Another fireman admitted that he is reluctant to come upstairs alone.

It may have taken a lot for grown firemen to admit their reluctance to go into these rooms alone, and it lends a lot more credence to the stories to hear it from their mouths. If it is the ghost of former firemen, then most agree these old-timers are somehow looking out for the firehouse and the men who currently occupy it.

MONTAUK MANOR

Located atop a hill looming over Montauk village is Montauk Manor. Driving up the hill with the enormous palatial hotel rising into the sky brings to mind images of *The Shining*. It is imposing yet elegant and ornate from the exterior to the main lobby. As you walk into the lobby and down its halls, you can almost feel Montauk Manor's history at your heels, as well as its ghosts.

The ground where Montauk Manor stands has had a checkered history full of ambition and dreams, as well as death and sorrow. It was the home

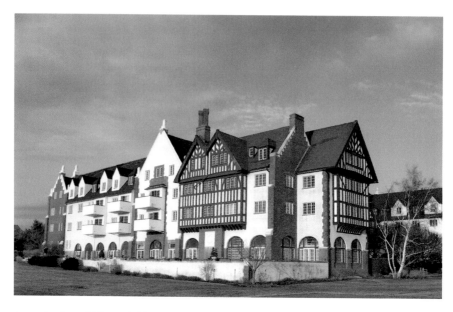

A scenic view of Montauk Manor taken not far from the Indian burial ground.

of the Montauketts, and the hill was once considered a holy place by many Native American tribes even as far away as the Canarsies in Brooklyn. They used the hill as a burial ground for revered members of their tribes, and the cemetery grounds can still be seen today.

And yet for such a place of peace, this hill was once soaked with blood. The Montauketts were a peaceful tribe that cooperated well with the settlers, but they were constantly at war with tribes across the water on Connecticut and Rhode Island. During one fierce and costly battle in which chief Wyandanch's daughter was kidnapped, the ground at the foot of Montauk Manor became known as Massacre Valley.

Yet again, Montauk was troubled when Theodore Roosevelt brought his Rough Riders to the hill in 1895. Sick with yellow fever, many of them did not survive the trek up the hilly countryside, and still more died afterward. The camp set up for the sick men was large and covered much of Montauk, including the grounds of Montauk Manor.

But Montauk Manor's history was not always filled with suffering. The hotel itself was created by Carl Fisher in 1925 as part of a dream to turn Montauk into a summer resort town much like Miami Beach, Florida. Within two years, his dream was turning into a reality with the opening of Montauk Manor, an English Tudor–style luxury hotel. Perhaps it was

simply timing and the arrival of the Great Depression, but Fisher's dream began to crumble into dust. Only the manor remains, renovated and flourishing even today.

So what do people claim to experience at Montauk Manor? An Indian chief with a headdress has been sighted at the foot of a bed and walking down the hall. We were told that two men on the second floor saw a black sphere roll across their floor only to dissolve before their eyes. A woman on the fourth floor in the winter, when there are very few guests, called the front desk in a panic. She was taking a shower and heard someone speaking a foreign language inside her room.

Someone came to investigate and left, satisfied that there were no intruders, only to receive another call as the foreign voices resumed moments later. There were currently no guests even close to her room. The most chilling story revolved around a family with a two-year-old. From the moment the family arrived, the two-year-old began screaming, "Ghost!" She carried on so much and for so long that the bewildered family had to cut their visit short and leave at 2:00 a.m.

In the deep of winter, we decided to stay a night with a group of friends at the manor to see if the rumors of its haunted halls rang true. We toured the lobby and walked the halls randomly, even after most guests were asleep, hoping for a glimpse of the Indian chief who supposedly wanders its hallways. But there was another rumor that we were investigating as well. On a TV program we had caught some time ago called *Secret Underground Bases*, it was suggested that the manor had a tunnel connecting it to Camp Hero.

So late at night, we wandered down to the basement and began looking for utility rooms or any hints of a tunnel. Strangely enough, we did find one maintenance room. John told me he had a strange feeling that his key would work in the door. He took out his room key, and it slid right into the lock and clicked open. Even though we were in the same room, my hotel key did not work, and neither did any of the other guest keys we tried. Our foray into the room to search for the tunnel was interrupted by a friend who pointed out overhead cameras in the hallway. We wandered back toward the elevators and stopped dead when the courtesy phone on the wall next to us began to ring. Tentatively, we picked it up, certain it had nothing to do with us. However, a voice on the other end asked, "What are you doing down there?"

Frightened, we made a hasty excuse, telling him we were searching for the pool, but the voice on the other end was unconvinced. Finally, we told him about the tunnel rumor. The last thing he said before hanging up was

that we should come to the front desk if we wanted to know more. As if that were not surprising enough, the elevator door opened on its own, seemingly beckoning us to come upstairs.

It took us some time to compose ourselves and gather the courage to pass by the front desk two hours later, but we had not been forgotten. The man at the front desk called out to us the minute we were within sight. What ensued was an in-depth, four-hour conversation delving into the depths of Montaukett history, as well as the manor's. It turns out the front desk manager that night was one of few people left on Long Island of Montaukett heritage, and he was very knowledgeable.

Amidst the gems of knowledge he passed on during our discussion, he had one thing to share that sent a shiver down our spines. While he agreed that the land had been used as a sacred burial ground by many tribes, there was a much more sordid side to the story. While the hotel was being constructed, bones were discovered in the area to be used as a foundation. These native remnants were mixed with lime and molded in with the foundation. Thus, if this is true, the hotel may really stand on the bones of ancient sachems.

In the end, we finally had to ask about the elevator and how he had cued it to open on demand. But he threw up his hands and told us that he has no elevator controls behind the desk; however, he did admit that we were not the only ones to experience elevators opening on their own. A second elevator did the same thing later that night as we were standing near it. It still remains a mystery.

While we did experience a number of odd coincidences, sadly we were not fortunate enough to witness one of the hotel's ghostly residents. However, we did leave with a much deeper respect for the history, a number of ghost stories and a desire for more. I doubt that this will be our last visit to Montauk Manor. Perhaps next time the phantom Indian chief will pay a visit to our bedside.

MURPH'S TAVERN

Every town on Long Island has its little niches and hangout spots, hidden gems frequented by locals for years and years. Sag Harbor is no different. Since 1976, Murph's Backstreet Tavern has been serving up cold brews and good company to locals and the occasional east ender tourist. Beneath all the music and merriment may lie a deeper story, that of the restless spirit of a woman named Aggie.

After retiring from the police force, Tom Murphy bought and opened "Murfs," as locals call it. He was known to be a good-hearted but stern ruler of the roost and was well loved by many in town. Unfazed by the odd incidents at the bar, he took pride in its spooky history. The building was built in 1792 as a private house. It was reportedly occupied by a woman named Adelaide King, who was supposedly raped and killed in her own home. According to Murphy, she may have lived in the 1940s.

At the bar, people have witnessed some strange things. A blender turned itself on, though the switch

Murph's Tavern in Sag Harbor.

was set in the off position. Animals seem to have odd reactions. A dog began barking fiercely up the stairs only to suddenly run away and hide. There is a chair that frequently flips over by itself, and a shot glass once flew into the owner's hand just as he reached for it, to the complete astonishment of customers. Sometimes bar-goers would hear furniture moving upstairs and would ask if anyone was up there.

Before the bar was even open for business, Murphy witnessed Aggie's antics firsthand. As he was doing work under a sink, he heard someone call, "Hello?" There was no reply, and when he stood up, he found the door to be open. As soon as he began walking toward the door to close it, it closed by itself. This was a heavy door that opened outward, so it is conceivable that the wind blew it closed, but wind could not have opened it in the first place.

While he enjoyed some of the notoriety of having a haunted bar and took it lightheartedly, there were times when even he was spooked. According to an article in the *Sag Harbor Express*, Murphy admits that there were some

times when a cold chill seemed to descend on him, and he would feel a strong urge to lock up and go home.

Thomas Murphy passed away in 2012, though the bar is still going strong. Perhaps, like Murphy's signature red barstool, Aggie and Murph's Backstreet Tavern will still be around for quite some time, livening up the quaint village of Sag Harbor.

KATIE'S PUB

In the heart of Smithtown lies a beloved and very haunted bar named Katie's. It is not uncommon for bars to be hosted in historic buildings with stories of their own, and Katie's is no different. From deep within the walls ooze rumors of shady Prohibition days, as well as the suicide of a former owner. And Brian, the feisty current owner, is likely to make his own mark on the building's history.

The building may have been used as a speakeasy during Prohibition, but we do know it became the J.H. Bishop Candy Shoppe in later years. After the candy shop closed, it was eventually turned into a stream of bars under different owners, all faring rather poorly in the end. Brian bought the bar for a few hundred dollars from a friend, also inheriting the bar's debts and business challenges. Through hard work and the sale of his home and beloved motorcycle, he was able to begin renovations. To further cover the costs, Brian rented out the downstairs to psychic mediums for readings. These visiting mediums would often tell Brian about a man named Charlie who seemed to be hanging around.

The existence of Charlie was even further corroborated years later by a visit from the popular TV show *Paranormal State*. As part of their initial research, they brought together a group of locals, excluding Brian, to gain some objective information. As it turned out, there was a Charlie. An older gentleman remembered a Charlie Stein who was a bartender at the very same bar.

Brian had only begun to scratch the surface of Katie's haunted past through comments from the visiting psychics, but he was soon to experience things firsthand. One evening, two girls were working the bar, one standing near the sink and the other a small distance away. Glasses from the overhead rack suddenly leapt out and smashed to the ground between the two girls. At the same time, one of the barmaids felt a wet hand on her back. Even though the wine glasses had been dried, they left

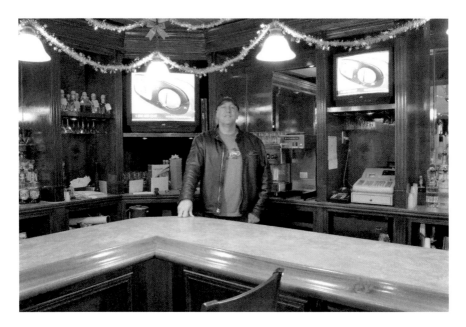

Brian, the owner of Katie's, inside his bar.

a strange wet residue where they fell. Perhaps old Charlie was just trying to pour himself a glass of bubbly?

This is not the only incident concerning flying glasses. In fact, you can find videos of similar instances on YouTube, posted by the owner himself. On one very recent occasion, the soda fountain nozzle even lifted up and hovered in the air for a few seconds.

From outside the building you can see an unused door that now would open into the men's room. It is a throwback from an older use of the building and is completely closed off from the inside. A man once claimed to see someone walk straight through the men's room door and into the bar as if there were no obstacles in his way. Ghosts often seem not to be aware of new structural changes to a building, sometimes wading up to the knee in floors that have been raised or using doors that are no longer there.

One of the most stunning and memorable stories we were told is that of Brian's phantom dog. His telling of the experience sent chills down my spine. Brian was often staying over at the bar on a couch downstairs. One night, he was awakened and found when he sat up that he was somehow outside of his body. To his shock, he could see himself still sleeping beneath him on the couch. His surprise was heightened when he saw his old pet dog coming down the stairs. The dog had passed away some six months prior and had been close to Brian's heart.

Glad to see his old pal, the dog and Brian played around a bit, but the dog kept backing toward the stairs as if it wanted Brian to follow. Over and over this happened. The dog even pulled on Brian's pant leg, becoming more and more insistent that Brian should follow him up the stairs. Finally, Brian tried to get the dog to do a very familiar trick that was well known around town. But to his amazement, the dog didn't seem to know the trick. Suddenly feeling uneasy, Brian realized that this might not be his long-lost dog after all. As soon as he said, "You're not my dog," the dog turned and ran.

But to Brian's horror, the event was not over. He found himself completely unable to move. Feeling growing anger at the vulnerable position the strange spirit had put him in, his feisty nature took over. He told the spirit, in no uncertain terms, that if this was it and he was going to die, Brian would kick its butt all the way across "sprit land." Suddenly, the weight was lifted, and Brian quickly left the basement and called a friend of his. To this day, he believes something wanted to lure him away from his body, and he feels that he might never have come back had he followed the phantom dog. The next day, the couch went in the trash, and Brian has never slept over in the basement of Katie's again.

Katie's Bar is now a fun yet elegant hangout that has its regular crowds and events. Brian has done a wonderful job breathing life back into the bar and continues to make it even better. The spirits are still very active and if anything have helped bring in the crowds hoping for a look at a flying wine glass or the smell of old Charlie's cigar. It truly is a bar that offers up "beer, wine, and spirits."

Old Bethpage Village Restoration

The only thing better than visiting a historic haunted house is visiting multiple historic haunts at the same time. The Old Bethpage Village Restoration houses a wealth of history and four possibly haunted buildings all in one place. It is truly a treasure and a fascinating place to visit.

As soon as you purchase a ticket and leave the main building, you find yourself on an old dirt path that leads you deeper into the village and further back in time, out of sight of your car and twenty-first-century civilization. At the end of that path is a restored village full of historic homes and businesses that have been transplanted from all over Long Island. Men and women in period clothes make you forget the world outside as they give you a glimpse into the world of the 1700s and 1800s. But when the crowds are thin and

staff members more relaxed, they will often tell stories of their encounters with the ghosts in several historic buildings.

The Williams House was built in the 1820s and is considered the most haunted house on the property. It is the home of Henry Williams, a farmer and carpenter. Many different things have been experienced here by many staff members. Sometimes footsteps are heard or the movement of furniture upstairs. A cleaning lady picked up a small toy teacup and heard a voice say, "Please put down my teacup." One female staff member was talking with visitors by the front door. She had noticed a frame on top of the fireplace, but when she turned around, the frame was now next to the doorway in the sitting room.

Interpreters are responsible for taking care of the house they are assigned to. One woman was scolded for leaving the iron out in the parlor, but she insisted she had not been the one to place it there. There is also a window that refused to stay open for one woman working in the kitchen. Every time she put a stick in the window, it would fall on top of the table, and the window would slam shut with a startlingly loud thud. The last time she put the stick in, she heard the window slam again. The staff member found that the stick was now over by a tree outside; much farther than it could have fallen on its own.

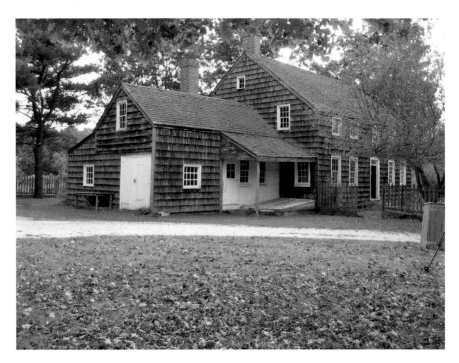

The Williams House at Bethpage Village.

It seems something at the Williams House does not appreciate doors and windows being propped open. Another woman told us she had to cook a turkey for Thanksgiving in the period kitchen. The heat was unbearable, and she tried to prop the kitchen door open for a breeze. She braced it with a long pole she found and sat back down on the table. She had just barely gotten settled when the pole hit her on the head. From where she had placed the pole, she could see no way for it to have fallen naturally and reach her in that way.

Ethel was Henry Williams's spinster sister. She was a seamstress and dressmaker. One of the ladies was in the house doing some spinning work, and she kept hearing noises coming from upstairs. Initially, she believed another staff member was in the house, but she later saw the other woman across the street. Startled and at a loss for the source of the noises, she ran over and convinced the other staff member to come and search the house. When they reached the upstairs room, they found a chest full of fabric that had somehow come open. Fabric was strewn all over the floor. They believe that was Esther's doing.

The Hewlett House is likely the second most haunted building on the property. It was built in 1796 by Charles Hewlett, a captain in the British army during the Revolutionary War. The Hewletts were a well-known family during that period. The last Hewlett to live there was Charles's descendant Lewis Hewlett from Great Neck. We believe that Lewis Hewlett may be trying to make his presence known. One of the female docents was stooped over working at the fireplace when she felt a hand touch her shoulder, pull her up and turn her around. Thinking someone wanted her attention, she looked, but there was no one there even though she could still feel a hand on her shoulder. Feeling a strange urge to look up, she did so. Above her, carved on the floorboards for the floor above, were the initials L.H., which can still be found today.

The house also has a notorious reputation among the security guards. Instead of skeleton keys, this house uses regular keys for the front door. It is easy for security guards to get locked in if they allow the door to close, and it happens all the time. The security system is in a closet off the stairway. One guard went in to turn off an alarm and heard the voices of two men in the basement. He called out in response at first, before realizing that two against one was not the best odds. He attempted to leave the house to get backup and found himself locked in. At this point, the guard was so spooked that instead of waiting for help, he climbed out the window. No one was found in the basement, and nothing in the house had been touched.

This house and the Williams House both have speakers to allow security to listen in remotely. On several occasions, the sounds of dogs barking or

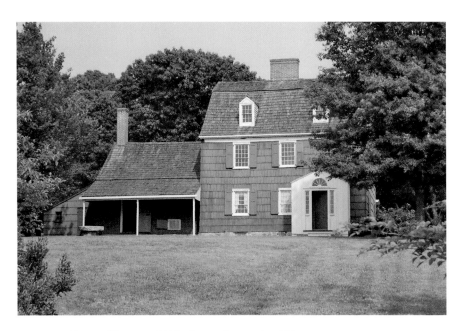

The Lewis Hewlett House at Old Bethpage Restoration Village.

people talking have been picked up, but when they go out to investigate, no one has been in the house, and all is quiet.

There is also a rather sad tale associated with the house. This was told to us by a staff member who knew the people involved. One woman who worked in the house always felt drawn to the stairs. On one day, the feeling was particularly strong. She climbed the stairs and saw, to her horror, a noose hanging at the top. She knew of another woman who had been pushed down the very same stairs, so both decided to perform a séance in the house. Supposedly, they were able to reach the spirit of Lewis Hewlett, who claimed to be the one seen hanging from the stairway. It has not yet been proven whether Lewis hanged himself from those stairs, but we have been told that the Hewlett family did undergo a period of hard times financially.

The third reportedly haunted house is the Conklin House. It was built in the 1820s by Thomas Hallock. The house sat next to his inn in Smithtown. While teaching school, it is believed that Walt Whitman stayed here for a time. The home was purchased by Joseph Hall Conklin after his marriage to Thankful Hallock, Thomas Hallock's niece. He was a simple man who ran a coach business until he moved to this house and became a bay man. The house, which was moved to the restoration village in 1965, is a fine example of a working-class house from the 1850s.

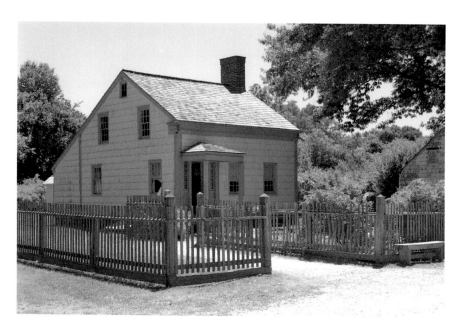

The Conklin House at Old Bethpage Restoration Village.

There are vague rumors of a deformed boy who was shut up in the house. We were told by one of the employees that a boy does indeed show up on the census, but only one time, and no record has been found after that. Our guide told us that some visitors approach the threshold and won't enter the house. There are also employees who refuse to work in the building. One woman who has worked here for over twenty years was assigned to the building. After her first day, she refused to work there ever again, and her wishes have been honored.

These houses are not the only haunted structures. In the heart of the restoration village sits the Noon Inn. It was originally built as an inn and bar. After its closing, the Noon Inn was bought out and used for storage by another company. Sometimes kids would break into the abandoned inn to play around. One man would sneak into the inn and use it as a place to sleep. From the story we were told, three teenagers came upon him while he was sleeping. He supposedly stabbed and killed two of the teens downstairs and the third upstairs in the bedroom. A security guard making rounds found the bodies, and the vagrant was caught with some of the teenagers' possessions. He later supposedly confessed to the crimes.

Later on, the story of the inn became a local haunted legend, attracting even more attention from local kids. One girl saw the faces of the three

murdered teenagers in the upstairs window. According to legend, their faces were spotted on the very night that the vagrant killer hanged himself in his jail cell. The entire macabre story is said to have taken place in East Meadow, where the inn once stood on the corner of East Meadow Avenue and Prospect Avenue. As far as we can tell, since the building was moved to Bethpage, there has not been any notable paranormal activity.

I highly recommend a visit to this wonderful restoration village, both for the history and the haunts. Come into the Noon Inn and sip some cider or birch beer and listen as the docents spin out a colorful tapestry of history. The village is restored to what it would have been in the mid-1800s, and it hosts many period events such as baseball games and reenactments. It is truly a wonderful place to shrug off the doldrums of modern times and immerse oneself in another era.

Pirate Jones

On Merrick Road sits a quiet little church that you might easily miss if you sneezed. But within its small cemetery is hidden the remnant of a fascinating story. You will find there the weathered and crumbling grave of "Pirate" Thomas Jones and perhaps the ethereal spirit of Mr. Jones as well.

Major Thomas Jones was the first of the illustrious Jones family to settle on Long Island in the seventeenth century. He built the first brick house in what was then Queens County. It was somewhat like a mansion in its day, being so large and different from the other homes. But the "Brick House," as locals called it, began to be known as one, if not the first, of Long Island's haunted houses soon after Jones's death.

Locals said the round window beneath the gable was haunted by the spirit of "Pirate" Thomas Jones. The reason for this conviction is that the window refused to be closed. Descendants of the major tried covering it with a sash, and the sash would inevitably be off by the next morning. Boarding, bricking or stoning the window were also unsuccessful. People passing the house claimed to hear wailing, shrieking and screaming coming from the window. Sadly, this most historic house was demolished in the 1800s.

It is little wonder that Jones's ghost was feared, given the rumors concerning his life and his supposed pirating. The illustrious Major Thomas Jones was commissioned by a letter of marque to command a privateer vessel from French ports. In short, he was permitted by government letter to commit legal acts of piracy as a privateer. But so many believed him a bold

and daring pirate that the rumor was nearly impossible to dispel; hence, the nickname "Pirate" Tom Jones.

When he passed on, it was believed that a hidden treasure of gold and silver was buried with him, and many a local pondered the idea of digging late at night for the riches. It was Major Jones's wish to be buried as close to tidewater as possible, so he was buried at the end of Fort Neck. Years later, his family decided to move him, and when they excavated his grave, all they could find was his skull.

It was this skull and the old tombstone that were moved into the peaceful cemetery at Grace Church. On the front of Jones's stone, it reads:

> *Here Lyes interd the Body of Major Thomas Jones, Who came from*
> *Straubane, in the kingdom of Ireland, Settled here, and Died December 1713*
> *From Distant Lands to This Wild Waste He Came.*
> *This Seat He Chose, and Here He Fixd His Name.*
> *Long May His Sons This Peaceful Spot Enjoy.*
> *And No Ill Fate His Offspring Here Annoy.*

Yet on the back side of the stone is a more spirited little poem giving just a hint of some of the rumors about Pirate Jones:

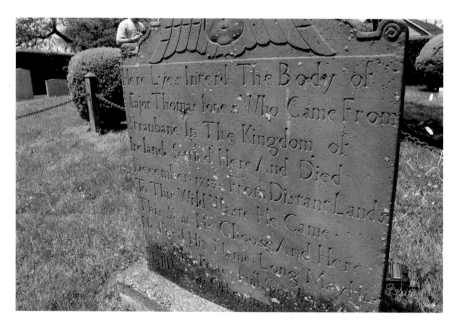

Pirate Jones's grave.

Beneath these stones
Repose the bones
Of Pirate Jones
This briny well
Contains the shell
The rest's in _____ [hell]

One of his sons went on to be a well-respected judge, and the Jones family descendants have truly made a name for themselves, but the echo of Major Thomas Jones's mixed reputation can still be seen today in remnants like this.

It seems that Jones may have left the property where his house once stood and now haunts his tombstone in Grace Church. We first visited the grave one warm summer day to see what we might find. With recorders, EMF sensors and thermometers, we camped out beside his grave in search of a sign, and we got what we came for. One of our thermometers had a probe that rested in the grass behind the stone. Suddenly, the temperature readings jumped to an unbelievable 114 degrees and climbing. Just as quickly as it had begun, the temperature began to drop again and stayed at normal levels for the duration of our visit. However, afterward, we found something strange on all of our audio recorders. A male voice seemed to say, "Dyin'" clearly, right at the peak of the unusually high temperatures. We later also picked up what sounded like "Yes, I'm dead." Both of these clips can be found on our website. To this day, we have been unable to find a satisfying explanation for that sudden spike.

It is a small and dilapidated tombstone that easily goes unnoticed. But that stone not only holds a key to the ghost stories passed down through the years but also a key to some of Long Island's early history and the history of the Jones family. It is another one of Long Island's little-known haunted gems.

Popper the Poltergeist

Sometimes things can change in an instant, turning your normal day-to-day world into something strange and unexplained. Such was the case with the Hermann family of Seaford, Long Island, on February 3, 1958. It was an ordinary day like any other when the Hermann children came home from school, but it quickly turned strange.

This unassuming suburban home was once home to Popper the Poltergeist.

Popping noises were heard throughout the house, and when the family went to investigate, they found that many bottles containing different liquids had popped their lids. Bottles throughout the house were affected, including bleach in the basement and even a bottle of holy water in the master bedroom. Bottles continued to pop their lids daily until James Hermann began to suspect his science-loving son of pulling a prank. Their attempts to find a rational explanation were stymied that Friday when a bottle of medicine moved across the top of the sink and fell, right in front of both James and his son. Unnerved and with no answers, the Hermanns called the police.

Despite his original disbelief, Officer James Hughes experienced the phenomenon first hand when several bottles in the bathroom fired their caps directly at him. Detective Joseph Tozzi was assigned to the case and took up his vigil at the Hermann house. He was witness to many strange things, some of which were even documented in newspapers. The strange goings-on at 1648 Redwood Path in Seaford soon became a public spectacle. The family was inundated with calls and letters from people offering rational explanations to religious fanatics urging them to "repent." One caller even informed the Hermanns that the Martians had landed.

But not all the unwanted visitors were unhelpful. Robert Zider from Brookhaven National Laboratories took notice of the case and suggested

that an underground stream beneath the property could be the cause. Thus began an exploration of many natural explanations. LILCO set up an oscilloscope in the Hermanns' basement but failed to find underground vibrations. Radio waves and sonic booms from jets also failed as possible explanations. Lastly, the family installed a rotary metal turbine in their chimney to stop downdrafts.

No sooner did the workmen install the device than a porcelain figure launched itself off of a table, hovered in the air and then smashed against a desk. It seemed "Popper the Poltergeist" was no longer content with bottles as things routinely began to move and fly about the house without warning. By February 20, things had taken a more energetic turn with the hurling of an ink bottle, a sugar bowl and more figurines. A reporter from the *London Evening News* watched his flashbulbs lift from the table before his very eyes.

Despite steadfastly supporting the Hermanns, Detective Tozzi was stymied. Specialists in parapsychology were brought in who suggested that all of this was perhaps something called PK, or psychokinesis. The theory was that preteens at the age of puberty could somehow release some sort of psychic energy without knowing it. They pointed out that young James Jr. was present during most of the incidents. Several parapsychologists from Duke University came to stay at the house and witnessed Popper flip over a night table in James Jr.'s bedroom.

It ended just as it had begun—suddenly—with the popping of one last bottle of bleach on March 10. After over sixty recorded incidents, Popper was never heard from again. And even after visits from detectives, reporters, electricians and plumbers, in the end no one could offer a full explanation for the events that plagued the Hermann family. Simply happy that the excitement had ceased, the Hermann family returned to their normal lives and tried to put Popper behind them forever. But the questions still exist. Exactly what did happen at the Hermanns'? And just what was Popper the Poltergeist?

RAYNHAM HALL

In quaint Oyster Bay lies a wonderful gem of haunted history harboring tales of spies, love and betrayal, as well as quite a few resident spirits. The white house on Main Street with the blue historic landmark sign in the front is called Raynham Hall and is currently operated as a museum. But it is Raynham Hall's place in Revolutionary War history that truly makes it unique.

Samuel Townsend purchased the house and property in 1738, when it consisted only of a small four-room home, an apple orchard and a small meadow, though he quickly enlarged the house to eight rooms. You will find the Townsend family name often in local history books, and Samuel was no different. An upstanding member of his community and a flourishing merchant, Townsend was also active in local government. Not only did he serve as justice of the peace and town clerk, but Samuel Townsend was also elected to a position on the New York Provincial Congress, whose initial purpose was to vote on and ratify the Declaration of Independence.

Shortly after the Battle of Long Island, Townsend was forced to house British soldiers and officers in his home despite his patriotic sentiments. Lieutenant Colonel Simcoe of the Queen's Rangers was quartered at Raynham Hall and was often visited by Major John Andre. It is around both of these gentlemen and Sally Townsend, Samuel Townsend's daughter, that the tragic story revolves. Both men were smitten by Sally Townsend, and it is a fact that they inscribed messages into Sally's bedroom windowpane with a diamond, etching them into the glass. Legend has it that Sally was in love with Major John Andre, though it was Lieutenant Simcoe who gave her what is known as the very first Valentine in America. (The names Sally and Sarah were used interchangeably in colonial days.) Below is just a snippet of the rather lengthy poem:

> *Fairest Maid, where all is fair*
> *Beauty's pride and Nature's care;*
> *To you my heart I must resign*
> *O choose me for your Valentine!*
> *Love, Mighty God! Thou know'st full well*
> *Where all thy Mother's graces dwell,*
> *Where they inhabit and combine*
> *To fix thy power with spells divine;*
>
> *Thou know'st what powerful magick lies*
> *Within the round of Sarah's eyes,*
> *Or darted thence like lightning fires*
> *And Heaven's own joys around inspires…*

One fateful day, poor Sally's hand was forced as she overheard a discussion between John Andre and others concerning Benedict Arnold handing over control of the fort at West Point to the British. Torn between love and ties to

family and country, in the end Sally told her father of the plans, which were then thwarted. Major Andre was hanged, and Sally was left alone, ending her days as a spinster. And it is where this broken love story ends that the haunted legends begin.

The house was eventually given by the Daughters of the American Revolution to the care of the Town of Oyster Bay, and many museum visitors and interpreters have had their own experiences with the house and its otherworldly occupants. Some say that Sally never truly left the house. Major John Andre has been sighted through one of the windows. A man in British soldier's attire has been reported wandering the grounds. And one of the upstairs bedrooms is always cold. Aromas from phantom apple pies are said to sometimes waft through the kitchen.

We had the pleasure to speak to a few of the museum interpreters and hear their tales firsthand. One of the biggest problems they have with the property is with the mannequins, namely the female mannequin in the dining room. This is because, long after the museum is closed and security alarms armed, she moves. Our docent told us she had been dragged back from her

This mannequin has set off a number of late-night alarms with its inexplicable movements.

home to check the museum a few times already because the security alarms were triggered. When she returned to the museum, the female mannequin would be in a different place.

Another interpreter told us of her very first ghostly encounter at Raynham Hall. She was new to the museum and happened to be doing rounds when the strong scent of apple and cinnamon wafted to her from the kitchen. But when she went to look, nothing was there. Upon mentioning the odd experience to other staff, she was told that this was one of the Townsends' servants welcoming her to the museum by baking a phantom pie. Apparently, it is a bit of a rite of passage amongst museum staff. The same staff member also recalled feeling a traveling cold spot in the hall by the servants' staircase.

There is another interesting aspect to the haunting of Raynham Hall in Oyster Bay, Long Island. It seems that paranormal activity may have followed the Townsends all the way from Raynham Hall in Norfolk, England. Their ancestral home, bearing the same name, is where the famous "Brown Lady" was photographed, a photograph that would travel the world and cause a sensation in paranormal circles. It is still one of the most well-known paranormal photographs today.

Is Raynham Hall haunted? It seems difficult to believe that a property and family so rich in history cannot leave at least some echo behind. And Sally and Andre's star-crossed story of love, spies and betrayal only lends more to the hope that something still remains at Raynham Hall beyond museum exhibits and furnishings, although the museum is well worth the visit with or without its specters.

SAGTIKOS MANOR

The words "historic" and "haunted" often go hand in hand, especially here on Long Island. Sitting quietly on a dark stretch of Montauk Highway in Bay Shore is Sagtikos Manor. The large white house, with its old-fashioned porches and shutters, is visible from the road. The manor is rich in history and local lore and also possibly rich in paranormal activity.

The work *sagtikos* means "head of the hissing snake," named so by the Secatogues for the snake-like river that passed through the land. We also know George Washington paid a visit to the manor on April 21, 1890. Sagtikos Manor's history spans over three centuries. The manor had strong connections to the well-known, historical and influential families in its time. In 1692, Van Cortlandt

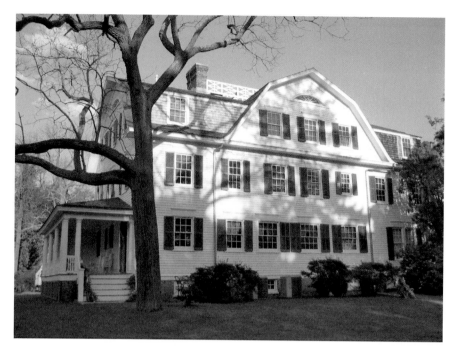

Sagtikos Manor, located in Bay Shore.

Trellis and benches in the back of Sagtikos Manor.

purchased the land from the Secatogue tribe. From the Van Cortlandts, the property passed to the Thompson family, owned by Isaac Thompson and his wife, Mary Gardiner of the famous Gardiner family. The manor continued to be used as a summer house. Its last occupant in 1985 was Robert David Lyon Gardiner, who willed the property to his own foundation. In 2002, the property came under the ownership of Suffolk County as the park we know today.

We know that Long Island Native Americans coexisted peacefully with the manor's owners and were often on the property. It is from them that we find our first ghost story. As told to us by a museum docent, one day long ago there was a fierce storm brewing. Some of the men were over on Fire Island with no way to get back. An Indian maiden and two braves took a canoe and led a daring rescue mission. Over and over, they made trips ferrying men across the water back home. But on the last trip, the canoe never returned. To this day, people claim to see an Indian maiden on the grounds or two young Indian men hauling a canoe. Also of note is a plaque nailed to a tree. It commemorates the grave of an unknown Indian girl who may have been accidentally shot.

There is also another tragic story. One young woman residing in the house once fell in love with a man from a neighboring property and made plans to elope and marry. On the morning he was to pick her up, she waited alongside the road. But instead, she was run down by a wagon and never got to meet her beloved. People driving alongside the road have reported seeing a woman in white in the road. She is said to sometimes be the cause of accidents when drivers run off the road.

Sagtikos Manor is one of our favorite local haunts, and we have been on many tours. Each time, we have been fortunate to collect stories from the docents there. Quite a few of them believe that Robert David Lyon Gardiner still pays visits to his home. One of the women was in the house alone with an electrician. Standing in the dining room, she heard the doorknob turn. Curious, she approached the door, thinking it was a visitor who was unaware that the house was closed. But the outer screen door was locked, and there would be no way to turn the inner doorknob without opening that screen door first. This was almost exactly two weeks after Gardiner's death, so she firmly believes it was Gardiner trying to get in. Another docent was passing by Gardiner's room on the second floor. On a lark, she said, "Hello, Mr. Gardiner" and knocked on the door. To her astonishment, a succession of raps came in answer.

Whether it is Gardiner or one of the other former residents, sometimes it seems the ghost can be helpful. Just before one of the house tours, a young

harpist went to gather some batteries to light the electronic candles. When she returned to the room, she found the candles already lit. The harpist asked the other docent if she had put in the batteries, and both denied having done so. Finally, they opened the candles and found that, though they were lit, they contained no batteries at all. Workers have also heard footsteps on the third floor. The door into the dining room opens and closes. Also, children's shuffling feet can sometimes be heard in the children's rooms.

One of the most interesting stories is that of George Washington's white horse, which is seen wandering the property. The young harpist and docent we interviewed told us she has seen this in person. It was not necessarily a horse in her view, but it was white and larger than a person. I find this so interesting because we have seen swoops of something white in the corners of our vision while walking the grounds at night.

In a three-century-old manor house that contains echoes of the blood, sweat and tears of many noteworthy residents, it is little wonder that it could be haunted. With so many personal accounts told to us by so many different people, I tend to believe that the stories bear some truth. However, even a skeptic will thoroughly enjoy the open tours of this wonderful historic Long Island home.

Reid Ice Cream

Everyone loves good old-fashioned ice cream. It is a delicacy that conjures up childhood memories thought long forgotten. Reid Ice Cream has been around since at least 1918 and was quite a local favorite all over Long Island, as you can see from the many advertisements of local establishments boasting that they carry Reid Ice Cream. In the 1920s, Reid opened a storage location on Atlantic Avenue in Blue Point. But over the years, this happy place would collect a not-so-happy history.

The first story is tragic but vague. Sometime in the early to mid-1900s, a young boy was killed on the property. The stories vary somewhat, but he may have been mentally retarded. He often played on the property, which runs alongside train tracks. According to local legends, he was hit by a train one day and died on the property of Reid Ice Cream. Since it was his favorite place to play, his spirit lingers there still. Some have heard children's laughter, and those who have wandered into the warehouse sometimes mention sounds as if a child were clambering around the equipment.

Later on in the 1950s or '60s, another tragic incident happened on the property. As the story was passed on to us, a woman believed to have been a go-go dancer slipped into the warehouse late at night with a male "customer" for privacy. It was the last thing she ever did, as she was supposedly brutally murdered and left in the woods outside the warehouse. Even years later, some report hearing a woman's piercing scream and cries.

Intrigued, we drove out to investigate and were lucky to come at a time when some contractors were going through the abandoned and defunct warehouse. We approached them, and they were wary at first until we explained why we had come. Their boss came running over to us then and let us know that not long before we arrived they had all had a strange experience. There was a heavy metal sliding door on the loading dock that they were using to enter and exit the warehouse. At about 10:00 a.m., the door suddenly began to shake, becoming more and more forceful. One of the workers stepped outside but could find no excuse for the shaking, which stopped after a moment or two. No train had been passing at the time, and the incident never happened again.

Even after the warehouse was demolished, people continued to have experiences. In fact, one of the most interesting experiences occurred months after demolition, when Reid was just a vacant lot strewn with bricks. The story of the murdered dancer was of great interest to us, as we received a rather interesting e-mail from a man we'll call Red. Red worked as a director for a manufacturing company and seemed quite literate. He was not a believer in ghosts until one particular night that shook him enough to contact us—and to stay in contact with us for some time afterward. Riding home on his bicycle late one night, he passed the now-abandoned warehouse and spotted a woman standing on the edge of the property, but as he came closer, he could see that she had no eyes. There were simply black holes where her eyes should be. The woman promptly vanished, leaving behind a shocked and frightened witness.

Besides the reports of children's laughter and a woman's screams, people have also reported seeing odd lights on the lot. As of our last visit, two houses were built on the lot and are awaiting occupants. The old ice cream company warehouse is gone but certainly not forgotten, especially by its otherworldly occupants.

WHITNEY TOWER

Often we find history, and hauntings, hiding in plain sight. The Old Westbury Golf and Country Club, lying right near the SUNY–Old

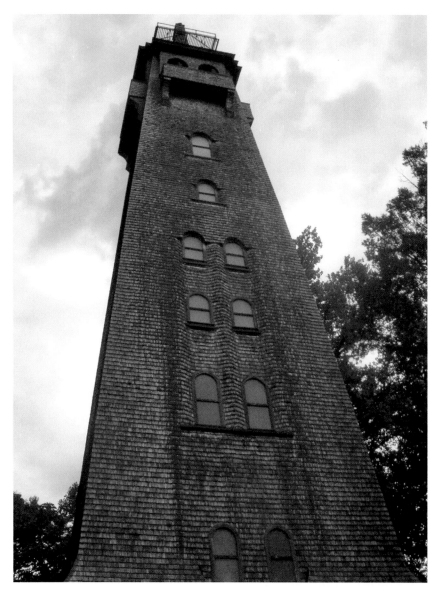

The supposedly haunted tower from the Whitney estate. It now sits in the middle of a golf course.

Westbury campus, has its own secret—that of a water tower leftover from a Gold Coast–era estate. The golfers putting beneath the watchful eye of the Whitney Tower have no inkling of the deeper story—that of unrequited love and suicide.

Prior to the turn of the twentieth century, William C. Whitney purchased and built his estate on the property, including the water tower around which this story flows. The estate passed to his son Harry Payne Whitney in 1904. Harry married Gertrude Vanderbilt, an enthusiastic supporter of sculpture and other artistic endeavors. A sculptor herself, she eventually founded the Whitney Museum of American Art in New York.

It was through her love of sculpture that Gertrude met Gaitan Ardisson, a sculptor who came under her employ at the property in Old Westbury. The situation that led him to his death is unclear, but rumor says that he was in love with Gertrude. According to the stories, he was creating a sculpture of Gertrude as an expression of his love. But Gertrude did not return his feelings and refused to attend the unveiling of the statue.

This we do know for a fact: Inconsolable and distraught, Gaitan climbed to the top of the one-hundred-foot-tall water tower and leapt to his death. He was seventy-four years old when he died, and the note he left behind is still somewhat a mystery. To his son he said, "Mrs. Whitney—you win; Tan Tan, tout est attaint." The latter part translates as: "Tan Tan, all is ended."

While we are unsure what Mrs. Whitney may have done to drive a seventy-four-year-old sculptor to such an extreme act, it was apparently enough to continue to haunt him even after his deadly plunge. Some say they have heard a tortured scream from inside the tower, and some believe they have seen something, or someone, moving in the windows.

If the Whitney estate water tower is indeed haunted by the spirit of Gaitan Ardisson, then perhaps it can be said that his love for Gertrude truly does extend beyond the grave.

FIRE ISLAND LAND PIRATE: JEREMIAH SMITH

Fire Island has long been a place of legends and mystery. Even the history behind its name can only be surmised. The island has a rich history and a reputation for adventure, playing an important part in Long Island history from whaling days to rumrunners in Prohibition times and beyond. Daring stormy rescues were made. Pirates and looters once roamed its shores, setting fires and wrecking passing ships. And even though Fire Island has changed so drastically over the years, echoes of the past still leave their footprints in the shifting sands.

There are a few theories offered to explain the name Fire Island. When I was a little girl, I was told it was because at sunset the sun glinted off the

water and looked like fire. Others relate the name to the Dutch word for "four," which is *vier*, and suggest that it was likely misspelled on some maps because of the way vier is pronounced. The use of vier may have been because at the time there were four islands.

Still others believe the name goes back to a more colorful history of pirates, smugglers and looters. Legitimate fires would often be set at night to guide ships away from dangerous sandbars and aid in navigation. However, land pirates and those called wreckers built fake fires to steer the ships wrong and run them aground.

Such a man was Jeremiah Smith, possibly the first Fire Island resident and black sheep of the illustrious Smith family. Smith built his home near where Cherry Grove is now. He is solely responsible for many wreck robberies in his time, and his methods were more than unscrupulous. Once his fires misled a ship and it wrecked on the sandbar, Jeremiah would invite the survivors into his home, kindly offering shelter and warmth, and then he would poison each and every one of them. Once the passengers and crew were dispatched, Smith could take his time stripping the ship of everything it was worth.

While Jeremiah was not the only wrecker and murderer on Fire Island, he was quite possibly the first and the best. However, fate changed for Smith when he decided to take in an assistant, a "dark-visaged man," according to the story, to help him fence the items he stole and to bury the bodies. The two men in turn enlisted the help of two ladies, though it is unknown what role they played. The ladies turned the two men against each other, and things finally came to a head. A sword fight ensued between Jeremiah and his assistant. It continued until both of them were dead, and this is where the ghost story begins.

We had the pleasure to meet Dick Barrett, a former Suffolk County police officer and Fire Island National Seashore ranger for many years. His wealth of knowledge on Fire Island is formidable, as are his stories of firsthand paranormal encounters. He told us a chilling story about Jeremiah Smith that we will never forget. Dick Barrett was driving along on patrol one night when he heard a faint clanging noise from somewhere in the dunes. It continued repeatedly for a moment or two, and Barrett left the car to investigate. The sounds ceased, but what he found in the sand was even stranger. There, amidst the dunes, were two sets of boot prints that circled around each other. And what was odder still was that the impressions the boots left were symmetrical on both sides, not made for right and left feet like today's shoes are. He later discovered that in the early to mid-1800s, shoes

and boots were made the same way for both feet. He believes these footprints could have been made by two men of another time, perhaps reliving their duel in the dunes.

Jeremiah and the dark-visaged man are not the only ones Dick Barrett may have run into while patrolling the beach. At Watch Hill, Barrett once heard giggling and noticed two children in raincoats speaking a foreign language. Before his eyes, the children disappeared, not even leaving footprints.

Fire Island also holds its sad stories, and such is the case of Whistling Sam. He was the cook on the schooner *Louis V. Place*, which shipwrecked off of a sand bar near the beach during a severe ice storm. More on this shipwreck and its other haunting can be found under the Lakeview Cemetery section of this book. Of the entire crew, only two were carried off alive. As rescuers were sending bodies to burial at various places, they came across African American cook Whistling Sam, a well-loved member of the crew. Misled by the prejudices of their time, rescuers buried him in the sands instead of giving him a Christian burial as they did the others. When they later found that Sam was in fact American and Christian, men went back for him but were mysteriously unable to find the body.

Up until the mid-1950s, people sometimes reported seeing a black man wearing a pea coat wandering along the shore while whistling a tune. It has been suggested that Whistling Sam's spirit continued to roam restless until the final survivor of the wreck passed away, and then he, too, was allowed to fade into oblivion.

Having had such a strong impact on our history, it is no wonder that legends from Fire Island still live on in our folklore today. In addition to the beautiful natural scenery and beaches, it is yet another treasure to cherish and another great part of Long Island's past, present and future.

Chapter 4

CLOSE ENCOUNTERS OF THE ODD KIND

THE UFO CRASH AT SOUTHAVEN

It seems that anything weird anywhere in the nation has a Long Island version. If Camp Hero is our own Area 51 in a state park, then this story is our own Roswell in a county park. According to the now-defunct Long Island UFO Network (LIUFON, pronounced "Lou-fon"), a cigar-shaped craft was witnessed flying alongside Sunrise Highway. It turned north, headed to Yaphank and exploded. This supposedly occurred on November 24, 1992.

The Long Island UFO Network was formed in the 1980s by John Ford. Ford was a court officer who believes that Long Island is a hotbed of UFO activity. For the past several years, John Ford has been residing in Mid-Hudson Psychiatric Center, a maximum-security facility for the mentally disturbed. This would make it easy to write off John Ford as a "UFO nut," but the way he wound up in an institution leaves a lot of unanswered questions and actually lends to his credibility.

A few years after the Southaven Park investigation, John Ford was arrested for plotting to kill a local political figure, John Powell. Allegedly, Ford planned to poison Powell's toothpaste with radium he had obtained. The radium Ford was found with was a low-level radiation source used to calibrate equipment. It would probably take decades to cause harm, if any. Plus, how was he going to put the substance in Powell's toothpaste. The entire plot was recorded by a paid informant who joined LIUFON. The recording

is barely audible, and it appears Ford was being led by the informant in the form of joking around. John Ford was offered an insanity plea to avoid trial, and he took it, landing him a permanent stay in an institute for mental health. The story of John's arrest seems more bizarre than the UFO crash he was investigating and reeks of some kind of cover-up. Ford's mother was involved in Suffolk County politics, and Powell was later convicted for his role in political corruption. Perhaps that had something to do with it, or maybe it was because of his investigations.

I decided it was best to sort out the facts by going right to the source. In doing so, I was able to call and visit with John Ford at Mid-Hudson. I asked him about the Southaven Park crash, other UFO activities and his incarceration. His answers were very interesting.

"Mr. Ford, how did you wind up in here at Mid-Hudson?"

"They think I'm crazy because I believe in UFOs. That's why they put me in here," he said. "When we disclosed the Southaven Park incident, I was informed by a contact I have in the intelligence community that we caused the Suffolk County government a lot of problems, and they had to do a lot of covering up."

"Can you tell me what happened at Southaven Park?"

"You had a very large spacecraft, maybe about three hundred feet in diameter, enter the earth's atmosphere that night. As it came down in the area over police headquarters, it exploded. What had come down inside Southaven Park was an escape pod from the main ship, and wreckage from the main ship fell all over the place. A good chunk of it fell down behind police headquarters and also impacted inside Brookhaven National Laboratories (BNL)."

"Did LIUFON find any evidence of this crash?"

"We found a couple of pieces of it. We found one piece that was made out of pure iron with no trace elements. Another piece was highly polished platinum with traces of silver and nickel. We suspect it's from the ship. We are aware that some of the fireman who responded took some pieces of the wreckage home with them. We spent six months searching Southaven Park for the crash site. We found a fire road that was inexplicably widened and resurfaced with sand from Smiths Point Beach. Trees were cut down to cover up a forest fire, and all of this was done by Brookhaven Labs. We know for a fact that Brookhaven was in there for three of four weeks removing sand from that road. Why? Maybe because of radioactive contamination or particles from the crash. We found radiation all over the park. BNL's fire department was called to fight the fires in the park for one reason: because they had training fighting radioactive fires."

"Was this the only crash of a UFO on Long Island?"

"There have been several crashes. One occurred by Montauk in February 1982. It was a wedge-shaped craft about twenty feet by twenty feet. It was flown into Westhampton Air Force Base and the next day delivered to Wright-Patterson Air Force Base. There was another crash in Southaven Park back in 1993. A wedge-shaped object came down behind the shotgun range. It caused a brush fire. It was brought to Brookhaven labs for study."

"Do you think your arrest was a cover-up?"

"This happening to me proves one thing. We are an effective organization. We fought the cover up, and this was done to destroy the organization and destroy me."

"Why did you take an insanity plea and not fight it out in court then?"

"I took the insanity plea because it was the only way out. I had a lot of pressure on me, and other reasons why I took it, mostly financially and family wise. I took an insanity plea, and it doesn't mean anything."

"Did you possess radioactive material?"

"It was harmless! It was radium to calibrate my Geiger counters. We just bought three or four new Geiger counters for the organization, and they needed to be recalibrated. It was about the size of a quarter and totally harmless."

I have interviewed seven former members of LIUFON, and they have all confirmed that the radium was harmless and intended to calibrate equipment used for hunting UFOs. When I questioned them about John Ford's mental state, they unanimously claim that Ford is harmless but that he was very particular about the way he ran his group. One former member also said that Ford wanted to bring a gun on an investigational outing in case they were accosted by authorities. All the former members have enormous admiration for John Ford and seemed uncomfortable saying anything negative about him.

LIUFON was co-founded by Richard Stout, whom I managed to track down. I went over to his house to interview him regarding LIUFON. He told me that he had left the organization before the Southaven crash, but he did have an experience at Southaven on more than one occasion. Prior to the alleged crash, he was in the park and found a dog that was bored straight through from his rectum. His insides were missing. On another occasion, he found a tree whose bark was peeled upward. "It was almost like all the bark and branches were sucked up by a huge vacuum, leaving it all at the top. It was weird, I tell you!" Richard goes on to say that he left the organization because he came to the conclusion that all UFOs are demonic manifestations organized by none other than Satan.

At first, this made me dismiss everything that Richard said as nonsense. However, the events of the next twenty-four hours made me think twice about that. I am almost reluctant to write this, as I find it barely believable myself, but I don't want to hold anything back from this story.

After I left Richard's house, at about 3:00 a.m., I headed home and went to bed. I felt something inside my mattress pushing at me. At first, I thought it was just a spring and tried to dismiss it. It persisted and forced me to no longer ignore it. I woke Laura, who in disbelief felt it herself. I then touched it again, and this time it went into my arm. I could feel it knocking through my skin. Laura placed her hand on my arm and felt it as well. It was very late, and we were both very tired; perhaps there is a logical explanation for this, but the timing is creepy. Earlier that evening, Richard had shared a strange story of his own concerning mattresses, so the coincidence was startling.

The next day, I went urban exploring a former military gun base. Inside one of the batteries, I found graffiti depicting little octopus-shaped aliens and the devil. From the devil's mouth was a text bubble that said, "UFO." Finding this gave me an odd sense of synchronicity.

This strange graffiti, apparently depicting a devil saying, "UFO," was found in an old military base.

Tom and Bill Sudbrink (brothers), along with Brian Leven, were once members of LIUFON and investigated the Southaven crash with John Ford. According to them, the park was closed for days after the crash. They attempted to fly a remote-controlled plane, equipped with a camera, over the park at that time. They say that a helicopter took off from Suffolk Police headquarters and interfered with the plane's electronics, causing it to crash.

During my investigation into all this, I started attending meetings at the Mutual UFO Network's (MUFON) Long Island branch. This is where I met some of the former members of LIUFON. One day, someone dropped a VHS tape in my lap and told me I would find its contents highly interesting. It contained a slide show and video clip that was shown publicly by LIUFON. LIUFON would give lectures and presentations for financial compensation, and this tape must have been one of its shows. On the tape, I found a picture of the former LIUFON members with the remote craft. Their ages in the tape clearly put it around the time of the alleged crash. This made their story that much more credible. The tape ended with footage narrated by John Ford claiming to show the crash site directly after impact. It showed what appeared to be some sort of smooth, rippled foil with a dry ice–type mist emerging from it. Then someone walks by, blocking the view, carrying something in his arms. Ford claims this was an extraterrestrial being on its way to BNL. He then goes on to point out other beings on single frames of the video but claims they move too fast to be shown clearly. This would require an enormous speed. I couldn't see any of these beings.

Walking around Southaven Park, I did find an area where all the trees seemed to be growing on a tilt. Behind the shotgun range, I found a large area of sand that from an aerial photo looks like it could have been an impact site. However, nothing I found seemed conclusive. Like the Montauk Project, the Southaven Crash may seem dismissible, but there are some elements of the stories that keep you wondering.

THE CAMP HERO PROJECT

A defunct military base, with a gigantic radar tower in the middle, turned into a state park is pretty darn weird, but this isn't where the story ends. Camp Hero, located on Montauk Point, sits next to the historic Montauk Point Lighthouse. The really weird part is that for the past twenty years,

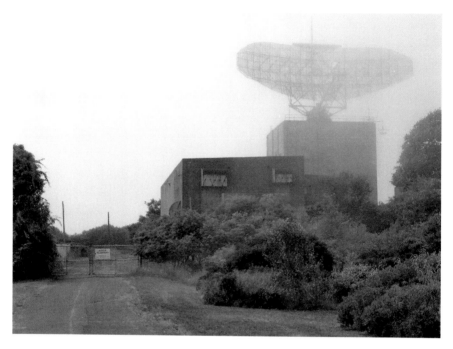

The radar tower at Camp Hero.

Camp Hero has been attributed to conspiracy theories involving aliens, mind control, time travel and a four-dimensional creature named Junior.

Camp Hero's humble beginnings go back to 1929, when it was commissioned as a fort. It remained so throughout World War II. It contained large guns designed to shoot enemy naval ships. The ammunition was stored in bunker-like structures. The supporting buildings were all disguised to appear like they were part of a small fishing village. The gym looks like a church, the barracks like a hotel and the mess hall like a restaurant. A fire control tower used to spot incoming enemy vessels and figure out coordinates is designed to look like a cottage. Meanwhile, it is constructed largely of concrete molded to look like shingles. Those buildings are today vacant and boarded up on the state park, adding to the creepy nature along with the legends. The entrances to the underground batteries are on display throughout the park as well.

After it became antiquated by newer technology, the air force took over the site in the mid-1940s. It became the Montauk Air Force Station and was used as a radar base to spot an aerial attack. A radar tower called a SAGE (Semi-Automatic Ground Environment) tower was constructed. Its purpose

The entrance to one of the batteries at Camp Hero, where the Montauk Project was alleged to have occurred.

was to look beyond the horizon for a Cold War attack by aircraft. It, too, eventually became antiquated, and the entire base was decommissioned in 1980. The SAGE tower still stands as a rusting, Cold War–era monolith. It not only adds to the legend but is also at the very heart of it.

According to legend, after the base was decommissioned, it was used for experiments in mind control. The radar tower supposedly contained a chair that was connected to mind-amplifying circuitry. Kidnapped children known as the "Montauk Boys" would be placed in the chair to either have their minds read or have thoughts implanted. The experiments were supposedly overseen by military officials and reptilian-like aliens.

The root of the legend seems to be a series of books first appearing in 1992, written by Preston Nichols and Peter Moon. After reading the books, I came across a VHS tape called *The Montauk Tour* at a video store. It was narrated by Preston and gives a tour of the base in 1993, before it was a state park. Preston points out a large round building that was once the base of another radar and states that it was a "UFO landing pad." He goes on to point out Junior, a Bigfoot-like creature, several times. Every time he does, I

see nothing but a speck of dust on a window. He brings a psychic into one of the batteries. She starts crying and saying how people were tortured there.

The legend goes that the experiments are still going on underground in a series of tunnels that go beyond Camp Hero State Park. We visited Camp Hero and gained entrance to several of the buildings. There was nothing really strange or disturbing about them. They were just decaying buildings. Then we entered the radar tower, and that was a different story. I wanted to see what was in its basement and if there was any evidence of tunnels. I first came upon the freight elevator. The door was open, but the elevator was on an upper floor. The shaft was exposed, and I could see that the shaft was flooded to exactly ground level. I have seen flooding in abandonments many times, but this appeared bizarre and artificially maintained at such a precise level. The water came right to the edge of the floor line, not a drop over or under. I went to another room that had a mesh floor that made it apparent there were levels below it. They, too, were flooded right to the top of the mesh. Was this done to hide something—perhaps the hidden underbelly of the Montauk Project? On an upper level, there was misspelled graffiti that said, "Montak Boyz," but I am almost certain that was just kids who heard the legends. There was electronic equipment scattered all over the many floors of the radar tower, and it certainly did radiate an ominous vibe.

I wanted to hear the stories behind the legend from the source. I met someone at a MUFON (Mutual UFO Network) meeting who told me that Peter Moon hosts monthly meetings at his house. Peter Moon is the coauthor of the Montauk Project books, along with Preston. This person eventually asked if I wanted to accompany him to one of the meetings, and I began showing up regularly. The first few meetings I attended didn't pertain to Montauk. Mostly new age and metaphysical topics were discussed. During one meeting, I came across a slovenly looking older man lying on the couch. I introduced myself and found out he was none other than Preston Nichols, the source of the Montauk Project legends. I began asking him questions, and some of what he was telling me made sense from an engineering perspective. I am a former electrical engineer and well versed on the subject. Other things Preston told me sounded like pure nonsense. The Montauk legend is very much the same. Sometimes it seemed like nonsense, but there was always something that made it seem genuine.

Since authoring the books, Preston has moved to Cairo, New York. While traveling upstate, I decided to drop in on him and see if he would give me an interview outside the busy meeting at Peter Moon's house. He lives in a former hotel converted to a home. It contains two buildings. His driveway

is a long path up a hill. Toward the top, I could hear the sound of a grinder. There was a man in the yard grinding a lawnmower blade. When he noticed me, he stopped and asked if I was looking for Preston. When asked what he was grinding, he told me he was making a machete to cut weeds. He went inside the larger of the buildings. I took that time to look around the yard of this compound and found some curiosities. The yard was littered with cars from various decades; some were seriously decayed. There was even an old school bus. Semi-hidden security cameras were all around, in house windows, mounted to trees—literally everywhere. If I had not previously heard that Preston owned all these cars before moving upstate, I would have thought I was in the midst of a serial killer's compound.

Preston came outside and took me into the smaller building. The hallway was lined with old electronic equipment and smelled of cat urine. A hoarder would have blushed at the site of this hallway. We entered a room on the other end of the hallway that was a little less cluttered. It had a bed in the middle with chairs around it. Over the bed was a bunch of little red and white infrared LED lights arranged in many columns. A wire harness emerged from the array of LEDs and went into an electronic device. There was a pyramid-shaped speaker and amplifiers with vacuum tubes. Preston flipped a switch, and the tubes started to glow orange. Preston told me the LED array, and its controlling circuit, was from the Montauk project. He played an oldies CD and told me it was recorded from someone's mind. "There is a part of the brain for each frequency component, and they form a matrix. If you can read that, you can hear or record what someone is listening to. The song you are hearing was being listened to by someone we recorded it from," explained Preston.

He then asked if I wanted to lie on the bed and look at the lights. Had I been alone, I would have said no, but I was with Laura and a friend. Curiosity got the better of me, and I tried it. He put on another CD, and the lights went wild. They pulsated with the music, but I felt no effect. I asked Preston if this was part of the Montauk mind control program, but his answer was unclear. He played "Blowing It All Sky High" by Jigsaw and told us this old song was actually brought back in time from the Preston Nichols of the future. That's right—Preston believes that on a few occasions, he has come in contact with his future self.

I got off the bed and asked him to explain the Montauk Project to me:

"Preston, can you describe the Montauk Project in a nutshell?"

"The Montauk project started out as a research project that was an extension of MKUltra [a CIA mind control experiment]," he said, "in

A bed at Preston NicholS's house. He believes the lights and sound equipment can alter the mind.

order to learn how to use radio waves to affect how people think. It was literally electronic mind control. After awhile, it was discovered that the mind had the capability to warp time. The system at Montauk was a mind amplifier. It would pick a signal from someone sitting in a trance and align them with a computer. The thing put out maybe two terawatts of pulse power. When we were generating that enormous amount of power, we would notice that a person like Duncan Cameron [a self-proclaimed former Montauk Boy possessing psychic powers] could literally create solid objects out of the ether. At times, these functions would happen out of real time. They could happen before or after the transmission was done, most of the time during the time the transmission was done. At that point, the controllers got very excited, and that's when we shut down the mind aspect [of the project] and went into the nature of time. How can you bend time?"

"In the book and video, you mention Junior. What exactly is Junior?"

"Junior was basically out of the mind of Duncan Cameron. A bunch of us that were not in charge of the program got concerned [about] the direction the program was going in. So, it was decided to crash the project. Since literally that device had the capability [to crash the program], it was decided to have Duncan go into a trance, and when somebody said, 'The time is now,' he generated this creature that resembled Bigfoot, except [it was]

much taller and bigger, to crash the project, which it did. But then, when the transmitter was shut down, he [Junior] faded to another dimension. Later, when I returned with a ccd camera, I was able to film junior walking up and down a little hill. He seemed to be trapped in time, going back and forth."

I contacted Leo Pulaski, author *of Long Island's Military History*, to shed some light on the possibility of the Montauk Project. Leo was a member of the Coastal Defense Study group and wrote two books with sections about Camp Hero. Before his passing, he was considered by many to be an expert on Long Island military history. He told me that there were never any tunnels or underground structures at Camp Hero and that it wasn't common for military bases to have tunnels at all. The batteries, though they are covered with dirt and trees, are actually built above ground and have the soil placed over them. The batteries at Camp Hero are all in artificially created hills, and this is evident when you look at them.

While I was being interviewed by Oliver Peterson, a journalist for the *Southampton Press*, the topic of Montauk came up in passing. Oliver told me that when he was younger, he had found a tunnel near the lighthouse that led to one of the batteries and perhaps beyond. He described in detail where the entrance was. I searched for it and found a conglomerate of boulders that appeared to be placed there. So there must have been some kind of tunnel system.

More recently, in July 2008, something strange washed up on the beach at Montauk that some say bears a connection to Camp Hero and the Montauk Project. It made enough of a sensation to gain coverage on *Fox News*. Found on the beach was a dead animal unlike anything seen before. It had the bloated discolored body of what might have been a hairless dog or extremely large rat. But the mouth resembled a beak with teeth. Its front paw was also oddly elongated in a way that defied explanation. People began calling this bizarre carcass the "Montauk Monster," and a heated debate sparked about the origin of the strange animal.

While it seems that much of the legends and conspiracies surrounding Camp Hero are farfetched and difficult to believe, there is always some small nugget of truth that draws us in. While some say there are no underground tunnels or secret experiments, suddenly you are faced with what look like blocked tunnel entrances or flooded subfloors. The evidence in favor of the Montauk Project may not be enough to prove it, but it is certainly enough to leave a lingering mystery and many questions yet to be answered.

Chapter 5

PHANTASTIC LEGENDS

HEATHER'S WALL

We see many things on our routine drives to work, home or school. Often, we never give a thought to what we drive past in our day-to-day lives. But sometimes there are stories behind the ordinary things we pass. These hidden stories can be found all over Long Island if you only stop to look a bit deeper. There is a wall on Sheepshead Lane that is attached to a tragic legend of unrequited love.

Sheepshead Lane is a one-lane quiet road in Nassau County. The road is dark, with few streetlights and many overhanging trees. It is almost impossible to see without headlights at night. There is a wall that runs along part of the road, and locals call it "Heather's Wall" because of the broken love story passed on amongst local teens. It was passed on to us by a fan of the site awhile back, and of course we had to investigate.

The story goes that a young man fell in love with a girl named Heather who lived in a house behind the wall. They were together for quite some time and deeply in love, until Heather broke up with him suddenly. He did all he could to win her back but in the end accepted defeat. Heartbroken, he hanged himself from a tree outside her bedroom window, right near the wall. Before committing this final act, he wrote on the wall, "I love you, Heather."

To this day, if you drive down Sheepshead Lane, some say you can see the spray-painted message, though the wall has collected more graffiti over time. However, according to local folklore, this message changes. When drivers are leaving Sheepshead Lane, the message changes to "I loved you, Heather." Is

the addition of that simple "d" a message from her lover beyond the grave, or is it simply a trick of the eye? Opinions vary, but the sad story of Heather's Wall still survives today, lending an air of eeriness and mystery to a hidden, dark and quiet road.

LAKE RONKONKOMA

Long Island's early Native American history is full of stories and rich folklore, and Lake Ronkonkoma is such a place where history meets folklore and leaves us with ghostly legends that will likely never be forgotten. Located almost in the direct center of the island, the lake is both beloved and feared by the community living around it.

The exact details of the legends differ, as you will see, but they all involve an Indian princess, her unrequited love and desire for revenge. It is said that each year the lake will claim the life of a male swimmer. Despite safety measures and the watchful eyes of lifeguards, it is a fact that drownings did sometimes occur.

Lake Ronkonkoma, the legendary lake haunted by a Native American princess.

The lake has often been thought to be bottomless, containing an underwater passage to the Connetquot River or Great South Bay.

The Native American tribes of Long Island, especially the Shinnecocks, Canarsies and Montaukets, all took an interest in Lake Ronkonkoma and its seemingly mystical ability to rise and fall at will. They believed whenever someone drowned in the lake, their gods were displeased and would prove it by causing the body to be found washed ashore on another body of water, perhaps the Great South Bay. If the tribes located the drowned body and sacrificed their most beautiful maiden, all would be well; if not, they believed the lake would continue to rise until it swallowed the world. Signal fires were lit along the shore of the Great South Bay during the search, and when a body was found, the fires would be extinguished and relit, which would spread word to the entire island that a sacrifice was needed.

All of the maidens who gathered knew what their fate would hold if chosen. She would be highly honored and then brought into a canoe. When out on the water, braves would tie heavy stones to her feet, and as she called out asking for a blessing of her people, they would slowly lower her into the water until oblivion took her, though each believed a happy life would follow for them upon their deaths.

But there was one woman who was not so eager to be chosen. Her name was Woonanit, and it was certainly a twist of fate that the one woman who would be destined because of her beauty was the one woman who did not wish to be chosen. Woonanit had been betrothed to Wyandanche since childhood, and he was considered the best and the bravest of his time. He had recently become chief, and their wedding was to take place shortly.

Despite her best attempts not to decorate herself, she was indeed chosen for the sacrifice, and none but her fiancé objected. Chief Wyandanche tried to reason with the other chiefs, saying it was foolish to have these sacrifices and fear retribution from Manitou when they had done nothing to deserve it. He said that these ways should be left in the past. Left with only one last alternative, he gave the battle cry of the Montaukets and called his braves to him. They kidnapped Woonanit and hid her away.

Panic ensued as the waters of Lake Ronkonkoma continued to rise. For three days, their leaders gathered by the waters praying, until suddenly Wyandanche and Woonanit appeared. Both calmly stepped into the water, issuing an ultimatum that they would walk into the water until it covered their lips and stay there to await their fate. If the waters continued to rise, so be it. And if the waters fell, no more would they ever sacrifice a maiden to the lake. The waters fell, and the tradition was carried through no more.

But one has to imagine the number of Indian maidens whose bones still rest beneath the lake's still bottom if the story is true.

There is another version of this story that involves a vengeful maiden named Ronkonkoma who was in love with an English settler named Hugh Birdsall. Her father, Sachem Setauket, forbid the two from seeing each other, and both had to bide their time alone for seven years. One day, Birdsall received a message written on bark that on the next day his bride would be released to him. Instead, he found the maiden dead in her canoe, strewn with flowers all around. There are other versions of this tale that have the maiden rowing out to meet Hugh in the lake, but he never shows up. Broken-hearted, she ends her life and forever haunts the lake, seeking revenge by taking a man's life each year. Still other versions tell of Hugh Birdsall's death and the maiden's heartbreaking suicide upon hearing the news. It truly is a Romeo and Juliet story no matter which version you read.

In fact, the lake is about seventy feet deep and is not bottomless; nor is there an underwater passage to any other bodies of water. Because of the limited visibility, it is difficult to find someone once they go under, so it is not hard to imagine where the beliefs come from. Visibility disappears below ten feet in the lake, which also makes rescues difficult. There is a shelf that drops off into deep water rapidly, which can surprise swimmers. The lake does not rise and fall exactly according to local rainfall quantities, which is unusual.

While the stories themselves are poignant and filled with emotion, they would be easy to dismiss if not for the more modern personal experiences we have found. One of the most amazing stories involves a lifeguard of thirty-two years, David Igneri. According to him, of the thirty-two summers he worked, there were about thirty drownings, and all of them were males. He had a recurring nightmare that haunted him throughout the year of 1965 in which he was attempting to rescue someone and became disoriented in the dark, murky waters. When he reached the surface in the dream, he heard fireworks, and Igneri believed it was a forewarning of a drowning that would take place on the Fourth of July.

On that very day, an epileptic boy of fifteen had a seizure and went under. The staff of lifeguards did all they could, diving repeatedly for at least forty-five minutes, but could not find the boy. When Igneri resurfaced, there were indeed fireworks going off. We also found an article in *Newsday* from 2000 covering the drowning of Onix Ariel Umanzor, who was racing his friends to a buoy, fell behind and drowned. It took forty-five minutes for lifeguards to find him.

Strangely enough, the drowning in 2000 appears to be the last one documented, and there is one local Ronkonkoma resident who believes he knows why. On the

This mural, on the side of a Rosevale Avenue store, was painted by muralist Michael Murphy. It depicts the lady of Lake Ronkonkoma.

side of the Lakeside Deli in Ronkonkoma is an ever-changing mural depicting the Indian princess. Its painter, Murph, believes he was inspired to do the mural in order to appease her spirit, and he periodically revisits it to repaint and sometimes change the mural depending on his mood. Sometimes she is smaller, sometimes larger, looming closer to the water's edge. Often there is a tear in her eye. It does seem strange that reports of drownings seem to have vanished since the painting of the mural, so perhaps there is some truth to this story. Watching him paint was fascinating as we joined him one Sunday morning. He truly does have a passion for what he is doing.

We still sometimes hear stories from people we encounter. Some say they've seen the waters swirling around as if it were a toilet bowl being flushed, and others say they can see swirling currents even below the ice in winter, though the lake is usually eerily still. During a shoot for a short fictional film trailer, I actually had to dress up as the princess of the lake and dive into the water so I could emerge from below facing the camera for maximum effect. But I found that once I went completely under water, even though I had no sense of motion, I would always come up facing another direction, no matter how hard I tried to stay facing the shore. So perhaps there is a strange underlying current that runs through the lake.

Lake Ronkonkoma is beautiful and serene on the surface. It seems to call invitingly to swimmers and beachgoers. But beneath the surface, the deep waters may hide a long-held haunted secret. Whether you believe or not, these pieces of local folklore hold a fascination and contain a beauty of their own in the telling.

MARY HATCHET

Lizzie Borden had an axe,
She gave her mother 40 whacks.
When she saw what she had done,
She gave her father 41.

As kids, we knew this rhyme well, whispered from child to child on spooky slumber party nights. But little did we know that this macabre child's rhyme had connections so close to home, practically in our own backyards. According to local folklore, Long Island once had its own Lizzie Borden. And the details behind the supposed grisly murders have left us with a chilling paranormal story.

If you are familiar with many of Long Island's other legends, you may start to think that "Mary" is a scary name in these parts. Perhaps it is true, for the name is general enough to become the scapegoat of many a tale. The story goes like this. One day, possibly back in the 1800s, Mary took a hatchet and chopped up her entire family. Here the tale turns metaphysical. It is said that this grisly act filled the house with such evil that it sank into the ground, save the chimney, which was left sticking up all by itself. Word spread, and one group even turned it into a movie called *Blood Night*. In the movie, they invented a fabricated name for Mary and a detailed back story, but the core remains the same as what it has been for many years. This tale even inspired a song, called "Mary Hatchet," by a group named Deciding Tonight. The lyrics begin:

Mary had a little hatchet,
In a box sitting under her bed.
She held it close to her chest and she thought,
This would look great in the back of his head.

While the tale may sound farfetched, it is strongly believed by many young people in Nassau County who will swear they know just where the sunken

house is. We went on many a wild goose chase, trying to track down tips we received from several towns in Nassau County, and always came up empty and more confused. Lastly, we were contacted by someone with exact directions and were even told that there was rubble that could possibly come from a chimney on the grounds.

Of course, this news was both exciting and tempting after chasing so many dead-ends. We arrived to find a grass-covered vacant lot, but upon closer inspection, we did indeed find rubble beneath the tree and on the grass. It was in such shambles that we were unable to determine it if really was a chimney, but it was clear that something had once existed on that lot. All signs seemed to tell us we may have found the right place, but the case is still open, and we will continue searching until we can be sure.

We continue to receive e-mails about the legend of Mary Hatchet. Though not one of the most well-known legends here, it has a strong following. It is perhaps too chilling a tale to be easily forgotten in the annals of folklore.

MARY'S GRAVE

There are a few places that are brought up whenever we tell people about our work and our website. The first is often Mount Misery, but the second is almost always Mary's Grave. Actually, there is not just one Mary's Grave. There are several around Long Island connected to stories that are an ever-changing but important part of Long Island folklore.

One of the most well-known locations for Mary's Grave is Head of the Harbor, just north of Route 25A. Where Cordwood Path turns to Harbor Road lies a house at the heart of so many different legends about Mary. Across the street from that house is a concrete watershed. About two miles east is Shep Jones Road, where our Mary was hanged from a crooked tree. Her actual grave is said to be either in the backyard of the house or beneath the tree on Shep Jones. According to one account, there was a tombstone with the initials "M.S." at one time. The entire area is thick with legends passed on from teenager to teenager. We were fortunate to meet up with Richard Hawkins, a historian who collected handwritten accounts of the various Head of the Harbor "Mary" stories throughout the 1990s. His records are a wealth of knowledge and a wonderful insight into how stories change over time. Here are just a few of the many versions of this sad and macabre tale. Almost all of the stories involve a hanging and a tragic tale of broken love or deplorable cruelty.

Our Mary story from Head of the Harbor spans time itself, having taken place from anywhere prior to the Revolutionary War to as late as the 1960s, depending on which tale you follow. In early accounts, Mary was a witch in the 1500s or 1600s who fell under suspicion when locals noticed cats, dogs and horses disappearing. They tried to hang her from the limb of the tree near Shep Jones Road, but the next day locals saw her walking around town as if nothing had happened, carrying a noose around her neck. One teen wrote that Mary was chased out of town by the women of St. James on rumors that she had fooled around with their husbands, ending in her hanging. Others say she was murdered by her abusive father after finding she was pregnant or that her father committed rape and Mary chose to hang herself. Some say that she practiced Satanism inside the small concrete house.

There is also a love story. Local kids know a story in which Mary was in love with a man who was in the navy. She became pregnant with his child and soon after was notified of his death. Mary fell into insanity and hanged herself from a tree. The sad part of this tale is that the message was in error, and her boyfriend was said to have returned to find Mary and her baby dead. It is said that Mary sometimes returns to try to find her lost love. If she sees a man, she asks him his name. If it is not the one she is seeking, she kills him. There is a darker story about Mary and her baby. Supposedly, our Mary was walking the baby in a carriage along the road when she was accosted, raped and then killed by two men. They threw the baby into the woods. After the two men were found guilty, they reportedly died of unknown causes. Local kids say that on the year of her death, Mary rises from the grave to take the lives of two young men.

While the back stories can differ wildly, many local kids agree that Mary's ghost does not rest in peace. At the house where Mary's father is said to have resided, some locals reported lights flickering off and on. They claim you can see Mary's father in the window. There is always someone there, watching them as they drive by. I think it more likely to be the disgruntled homeowner who is plagued by a never-ending stream of kids gawking and creeping around his property. But the legend of Mary's father is persistent.

At night, the moon is said to always shine directly on her grave. One girl told a chilling tale concerning her friend's boyfriend. He was drunk and dancing on Mary's Grave, making all sorts of mischief. The next day, he was decapitated in a motorcycle accident. There are also many stories surrounding the tree on Shep Jones Road. One of them reminds me of the "Bloody Mary" game we used to play as kids, spinning around in a darkened bathroom calling her name until she appeared in the mirror—or you scared yourself so silly you ran out of the room. In this version, you must stand

under the tree and call her name while spinning around three times on the night of a full moon at midnight. Supposedly, the hanging apparition of Mary will appear. People also report having car trouble when stopping near the house. This includes cars stalling, broken windows and even a tree falling on a car. One group of teens got home to find themselves locked in their car for over fifteen minutes, unable to open the electronic door locks.

While Mary's Grave at Head of the Harbor is perhaps the most well-known location, it is not necessarily the strangest. The story of Mary at what was once the Chandler estate in Mount Sinai came to us under very strange circumstances. We had received some vague rumors for some time but were unable to narrow it down. We were exploring an abandoned building in the now-defunct Kings Park Psychiatric Hospital. Inside the building were shelves containing boxes upon boxes of records about calls to a hotline for former patients and their caregivers. Of all of the shelves, and all of the boxes, I pulled a small handful of records to read. What were the chances that out of those few pieces of paper would come the key to a mystery several towns away?

The Chandler estate was an abandoned property once owned by Mrs. Chandler, who rented it for lodging. At one point in the 1950s, Marilyn Monroe and Arthur Miller stayed there. Mrs. Chandler had some very interesting residents with their own unique stories. One woman used to yell at anyone who passed not to go into the woods. The property itself accumulated local legends about witchcraft. But the most interesting guest was Mary. Mary, whose last name we leave out for privacy reasons, was a former mental patient living there off social security.

Reading the page before me, I found a frantic call from a Mrs. Chandler in Mount Sinai. She stated that someone usually came every month to help Mary cash her check and pay the rent, but for the entire month no one had come, and she had not seen Mary. Mrs. Chandler went on to say that there was no sign of Mary by day in her room, but when Mrs. Chandler would come by at night, lights would turn on and off. She was too afraid to enter the room and thought Mary was missing. The call ended with officers being routed to her house, and we were left with the mystery of Mary. Local folklore talks about Mary's ghost roaming the property. On top of that document, we found further proof inside the abandoned Chandler estate buildings. On one of the upstairs bedroom doors are the words "Mary's Room" in stickered letters. We may never know what became of Mary. The buildings have now been demolished, but local legends about the property continue to flow in.

One of the other Mary's Grave hotspots is in Huntington, New York, on Mount Misery Road and Sweet Hollow Road. If these road names sound

familiar, I'm not surprised. Nowhere on Long Island is there a higher concentration of haunting legends. This Mary is also said to have been murdered in various ways, leaving her spirit in a state of unrest. Her story is often intertwined and mixed with that of the woman in white on Mount Misery Road, and she is also said to have a tombstone somewhere on Sweet Hollow Road. There is a well-cared-for cemetery in the area, but it may not be the location of Mary's grave after all. On one of our excursions, we found an old cemetery nearly buried in grass and brush. The only remnant was a historical marker nearly hidden away in bushes. Perhaps this is the cemetery of legend, though no tombstones remain above ground today. The stories say that you will see Mary's face appear on her tombstone if you shine a flashlight on it. Mary is also said to walk the darkened roadside where she was once run over, trying to protect other women from sharing her fate. I was once told that Mary's Grave was decorated by the statue of a child angel that cries real tears.

Long Island is not the only place to boast of a Mary's Grave ghost story. There is a "Midnight Mary" legend as far away as Connecticut. According to that story, those who disturb her grave at midnight could face death at the hands of Mary's vengeful spirit. As much as they vary, these stories seem to have some common threads running through them. Belief in these legends is not required to appreciate them as a living part of our folklore and heritage. They are a part of us, woven deeply into the tapestry of Long Island folklore.

MOUNT MISERY/SWEET HOLLOW ROAD

Of the most popular paranormal hot spots, Mount Misery and Sweet Hollow Road are probably the most well known. There is nowhere else in Long Island so full to bursting with ghost stories and eerie legends. From decapitated heads to hanging specters, Mount Misery Road and Sweet Hollow Road have it all. Located in Huntington, these two dark, tree-lined streets box off an area rich in mystery.

Mount Misery Road got its name in the early farming days of Long Island. It is hilly ground, and the soil was not very hospitable to farming, so it became a crossroads between communities. But the going was treacherous, and many a farmer lost a wagon wheel on the way, making it a miserable trip indeed. Nowadays, the road is probably equally as dangerous to vehicular traffic because of the dark, narrow, winding roads and constant flow of sightseers looking for a thrill. Teenagers like to shut off their headlights, engulfing their cars in

near complete darkness for full effect. To add to the risks, a local gang has recently taken to preying on paranormal sightseers as part of its initiation rite.

The oldest legend concerns the burning of a mental hospital in the late 1800s. According to the popular story, an older female patient found matches and set fire to her bed, burning herself and the hospital to the ground. She is said to be seen wandering the woods at the edge of the road, close to where the hospital was, in a white nightgown and with unruly white hair. Some say the stone steps to the hospital are there, buried by leaves in the woods, though we have yet to find them.

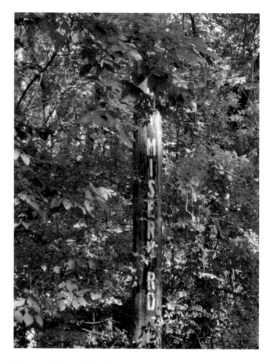

Mount Misery Road stenciled on a telephone pole alongside the road.

Mount Misery Road has some pretty fantastic legends. One is of a man who used to work at the nearby summer camp until he discovered a rather all-consuming macabre hobby. He collected decapitated heads in a basket and wandered up and down the road looking for someone new to add to the collection. While we can't say we have ever seen the former counselor turned murderer, we did receive a rather odd story once by e-mail. A young man named Dan was turning from Highhold Drive on to Mount Misery one night. He had his brights on, and he saw a shadow on the road from the corner if his eye. As he turned and his headlights touched the subject, he let out a startled yell and slammed on the brakes. In front of him, in the middle of the road, was a man in his seventies wearing what appeared to be a Cub Scout uniform. It was a navy-colored outfit with a yellow bandana tied at his neck. But the strangest thing was the hat, which resembled a World War II army private cap. Dan finally calmed his nerves and completed his turn, driving away with his heart pounding and coming home to e-mail us only an hour later. While the outfit could possibly match scout uniforms, these days the hats they wear are baseball caps.

Another bizarre legend concerns a police officer. According to the tale, people find themselves being pulled over by a police car at night and hand over their licenses and paperwork. However, when the officer turns around to walk back to the car, they can see in the mirror that he is missing the back of his head. It is suggested that this could be the ghost of an officer who was shot on this road, though so far we have found no concrete proof to back this up.

One of the more bizarre legends is that of the demon dog. Accounts say this is a large black dog with red eyes that lurks in the woods and by the roadside. Those who see him are supposed to meet a quick and untimely death, a mandate that conveniently leaves no witnesses. I am rather skeptical about this one, but we were contacted once by a person whose friend claims to have been a witness. He goes on in his e-mail to explain that the dog is none other than Cerberus, guardian of the gate to the underworld. According to his e-mail, all you really see are the red eyes; there is no body. He claims it leapt up onto his friend's car. As outlandish as that may seem, we also heard from a young woman who was out with friends and saw the red eyes of Mount Misery's phantom dog.

Mount Misery Road has its connections to the various Mary's Grave legends throughout the island. The woman who burned down the hospital has been called Mary, but there are also many stories about a young woman named Mary who was struck down by a car along the road. She is said to wander the roadside, sometimes stepping out in front of moving cars or trying to hitch a ride. There is also the grave of Mary, often said to be a young woman or child who was murdered. In some accounts, her tombstone bears a statue of a child angel that sheds real tears. In other stories, if you shine a light on her tombstone, you can see her ethereal face. This Mary is vengeful, too, and is said to attack those who disrespect her grave or threaten a woman alone on the road. There is a modern cemetery on Sweet Hollow Road, but we did also find a long-abandoned historical cemetery on Mount Misery Road. All that was left was a historical marker. All of the tombstones were gone except for a few odd bits of rubble, and it was terribly overgrown. But we wonder if perhaps this is the cemetery that is rumored to hold Mary's Grave.

While many of these stories are quite old, having been passed down in the usual way of urban legends, we have received a number of more recent accounts. An eleven-year-old girl wrote that her aunt had taken a drive to Mount Misery Road and pulled over to see if it "was really haunted." She claims to have spotted a headless man riding a horse along the trails. She also claims that a black car with tinted windows chased her and her friends from the road.

People also run into trouble with their cars. We have heard stories of engines mysteriously dying, of cellphone service suddenly getting cut off

when entering the area and of trouble starting the car again. But one story really took the cake. A woman went to the area with a number of friends, parking four cars along the roadside before wandering into the woods. When they returned, they found nearly every car window shattered. What they found strangest was that every window appeared to have shattered outward, showering the glass on the street instead of inside the car. Had someone come by to make mischief and shattered their windows, there would be glass inside the cars. This was beyond any explanation they could offer. While I can't completely vouch for the number of vehicle issues reported, I was once out with some friends who had slight engine trouble and ended up with a flat tire after driving only a few minutes away from Mount Misery Road.

While Mount Misery Road seems to have more than its share of the urban legends associated with the area, Sweet Hollow Road holds its own as a local attraction. There is a bridge overpass where Sweet Hollow Road passes underneath the parkway. This bridge is rumored to be a paranormal hotspot. The most well-known legend speaks of a teenager who hanged himself from the bridge many years ago. At night, people claim to see a brief silhouette of a hanging body under the bridge. There are also versions that tell of a triple hanging by three teens and the ghostly bodies of not one, but three, hanging overhead. We received a rather interesting e-mail concerning this bridge and a more recent version of the same tale. In this, a couple was driving along the road, and the boyfriend stopped under the bridge to get out and relieve himself. He never came back after wandering into the woods, and his terrified girlfriend shut herself in the car. She fell asleep and woke to see the sun shining. Stepping out of the car to search for her boyfriend, she took a look around and saw her boyfriend hanging from the bridge.

If that were not enough to draw fright-seekers to the bridge, there is yet another tale. Supposedly, a school bus full of children was driving in snowy conditions on the parkway, and the driver lost control when they were driving over the bridge. The bus fell off the bridge, killing every child on board. To this day, it is believed that if you park under the bridge and put your car in neutral, the children will push you free of danger. The ground under the bridge seems level, but your car will roll if you put it in neutral. There is a slight unnoticeable grade to the road. People also pour baby powder onto the hoods of their cars. When their cars roll out from under the bridge, they find handprints in the powder. While it is exciting to think that the prints are from the children's spirits, it is not necessarily so. Going about day-to-day, many people touch your car in passing or lean against it while you are parked, not to mention your own handprints. The powder picks up these handprints and accentuates them. And

as for the little handprints, who is more likely to touch things with their hands while out shopping or running errands with their parents than children?

I can say that there is something unusual about the bridge. If you walk under it with a compass, the needle will change direction by about ninety degrees once under the bridge. Whether this has something to do with the stone makeup of the bridge is still unknown, but it does add to the general strangeness surrounding it.

There is a woman referred to as the "Woman in White" who is often confused with the Mary legends. It is this woman who is described on roadsides, and she is said to leap in front of cars, much like one of the legends of Mary. Perhaps they are one and the same. She was supposedly sighted a few years ago by a fan of our site, who told us the frightening tale. They were driving down the road and had turned off their headlights to get maximum effect. As they followed along winding Sweet Hollow Road, they turned the headlights back on, only to witness a "flowing luminescent entity" cross the street and disappear into the woods. The form of the specter was vague and flowing but seemed to resemble the shape of a human wrapped in white, as if in a robe.

I admit that many of these urban legends can seem farfetched, and even some eyewitness stories leave at least some doubt and uncertainty. But it is strange that this one small area of Long Island has collected so many different and unconnected legends. According to Bill Knell, UFO researcher with the defunct group LIUFON, the area was considered taboo by local Native American tribes. Perhaps this area contains a special kind of energy that attracts paranormal activity. While it could also be that such dark and spooky roads cause the imagination to run amok, there are many other such similar roads on Long Island that have not accumulated any urban legends. There is clearly something special about Mount Misery and Sweet Hollow Road that has forever cast these roads into the annals of Long Island urban legend.

Jason's Rock

While England has Stonehenge and Easter Island has giant rock sculptures, Easthampton has Jason's Rock. Jason's rock is a mysterious marvel that is in between Old Northwest Road and Bulls Path. What makes this eight-foot rock mysterious is that there's a basin of water atop of it that's always filled, even in drought. About one hundred years ago, a black Native American named Jason used to hike from Easthampton to Sag Harbor to procure

booze. Easthampton used to be dry, while Sag Harbor was not. On his path, he would be seen stopping at the rock to fill his jug with water. On his return, he would again stop at the rock to mix water with his newly acquired whiskey. Nobody knows if the rock is named for this Jason or not. In the 1930s to 1960s, a wildflower expert would frequently visit the rock and measure the depth of water in its basin. He reported it was never less than an inch deep and was usually about six inches. There is no natural spring around the rock, and nobody knows how this is possible.

HERMITAGE OF THE RED OWL

What do anarchy and a talking owl have to do with Long Island? The 1800s was a century of newness. The country was young, and the industrial revolution was changing the way we lived. The concept of freedom brought people together in strange, experimental communities springing up all over the nation. Long Island's was "Modern Times," a community based on anarchy and equitable trade.

In 1851, Josiah Warren, an inventor and philosopher, manifested an idea where people would cooperate without profit. Josiah had previously lived in a communist-style community in Indiana. He and Pearl Andrews, a lawyer, purchased land in what is now Brentwood. They sold parcels cheaply to those who wanted to take part in the community. Residents would farm, build their own dwellings and trade with one another. A sort of currency, based on hours of labor, was printed and utilized. Josiah would travel and give lectures about his new community. A few Bostonians bought plots and moved in.

This brings us to our legend. One of the Bostonians was Charles A. Codman. On one particularly harsh winter night, his wife asked him to close their shutters. While doing so, he spotted a red owl in a nearby tree. "Poor Bird, out in the cold, wild storm. I would give thee better shelter if thou wouldst come to me," he said aloud to the owl. To his surprise, the bird answered, "Thou wouldst be kind to me?" The owl explained that he was an Indian chief whose life was cut down by a Mohawk Indian and that his bones lay in a nearby ravine. The owl asked Codman if he would find his remains and give them a proper burial.

The next day, Codman went down to the ravine, and sure enough, the Indian's bones were there. He buried them as the owl had asked. Three days later, he again saw the owl. The owl promised to bless Codman for his

kindness and then disappeared. Codman renamed his house the Hermitage of the Red Owl and adorned his fireplace with a portrait of the red owl.

So what ever happened to Codman and Modern Times? Codman continued to live in the same house until his passing in 1911, at eighty-three years of age. His neighbors noticed he had fallen ill and took him to the Ross Sanitarium for treatment, but Codman wanted to be in his beloved home. So they took him back, and that is where he passed. His house was where the Checkers is today. The dip in the shopping center's parking lot is where the ravine was, and the neighboring park offers a glimpse of what the area looked like when Codman found the owl.

As for Modern Times, it, too, came to an end. Well, sort of. By the 1860s, some of the residents were working outside the community and using real currency. Mary Grove Nichols, a feminist and promoter of free love, moved into the community because of the freedoms it offered. Modern Times began gaining a bad reputation as a society of sexual indulgences. The truth is that the vast majority of the community lived within the confines of monogamy, but the court of public opinion saw it differently. The people of Modern Times elected to have a public school, indicating they were becoming more like other neighborhoods. The onset of the Civil War was the proverbial last straw. In 1864, the remaining members of the community changed the area's name to Brentwood, after an English town. Today, there are still some lingering remains of Modern Times. On the corner of Third Avenue and Brentwood Road is an octagon-shaped small house. It was once the home of Upton Dame. He was a carpenter who took up residence in Modern Times. The house was built to maximize usable interior space. This was important because its second floor was a de facto meeting place for Modern Times's residents.

A GRAVE DIFFERENCE

GREEN BUNN AND BREWSTER BURIAL GROUNDS

The Green Bunn and Brewster Cemeteries sit on opposite sides of Bethpage Road in Copiague. What make them so unique are their monuments. Without the efforts of concerned locals over two different generations, these cemeteries would have been forgotten.

On the west side of the road is the Brewster Cemetery. Though many of the family names found engraved on the monuments sound European, they were actually names used by some of Long Island's Indians. According to the signage, the two cemeteries were for Long Island Native Americans and Civil War veterans. In the 1950s, three small statues were created at the Brewster Cemetery to memorialize three of its interred. The statues bear the inscriptions: "Florence H. Brewster, Sydney Brewster, and Charlie Carr Civil Wor [War] Veteran." These monuments were carved by Richard Brewster, son of Sydney and nephew of Florence. Richard is quoted as saying, "Some of my people fought for General Washington, and others were soldiers in the Civil War and Spanish American War, as well as other wars."

In the mid-1990s, locals fought to grant the cemeteries landmark status. McKinley Banks, a Copiague resident and Cherokee descendant, started researching the cemeteries in 1994. Eventually, the town got involved, and today new memorials have been placed in both cemeteries. The two similar memorials are made to look like pieces of tombstones with the names of the interred on them. A large stone in the center depicts a turtle, the Native American symbol

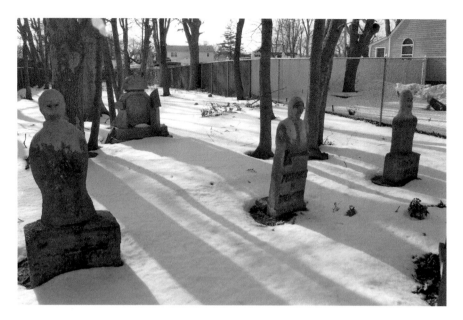

Memorial markers at the Brewster Cemetery in Copiague.

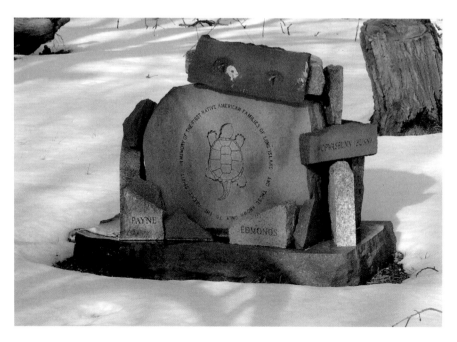

The Green Bunn Cemetery, across the street from the Brewster Cemetery in Copiague.

for the world. Around the turtle is inscribed, "In memory of the first Native American Families of Long Island and those known only to the Great Spirit." The Green- Bunn Cemetery on the east side of Bethpage Road contains the only original tombstone still left. It is so weathered that it cannot be read.

Home Depot Cemetery

Nineteenth-century cemeteries are common across Long Island. In fact, they are all over. What makes this one stand out is its juxtaposition. Today, it stands surrounded by a Home Depot parking lot. It was originally located between farm fields and was used to inter members of the Burr family.

The Burrs came to the New World from England in the 1630s and later arrived on Long Island in 1656. They had a farm, hotel and horse farm/racetrack in Commack. The Burr family was very prominent in Commack throughout the nineteenth century.

In 1918, the farm was converted into a U.S. training field for pilots on their way to France to fight in World War I. The cemetery, then surrounded by a white fence, sat in the middle of the airfield. After World War I, the area became

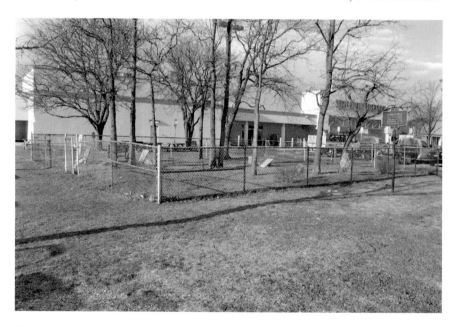

The old Burr Cemetery, now inside a Home Depot parking lot.

a farm once again, and the cemetery would not have seemed out of place. As Long Island began its conversion from being rural to suburban, the cemetery would once again find itself out of place. In the 1950s, a Modell's was built, and its parking lot surrounded the small rural cemetery. Nothing lasts forever, except perhaps the cemetery. Modell's moved out, and Home Depot moved in.

Lakeview Cemetery

I have never found cemeteries to be creepy like many do. To me, they are places of peace and quiet where you can walk amongst the stony relics of lives from long ago. Walking amidst these memorials, you can almost always find a story to intrigue you. There are always tombstone inscriptions that catch the eye. There is a large cemetery on Main Street in Patchogue that is full of interesting stories, if you only take the time to look.

Lakeview Cemetery was donated to the Episcopal Church over one hundred years ago by one of Patchogue's famous four sisters. They were the daughters of Micah Smith, who was influential in local politics. The Smith sisters became a household name in the southern end of Patchogue. In fact, Micah Smith once put forth a motion to consider that part of Patchogue a separate village, but the idea never fully took hold. There is a large plot containing the graves of the Smith family, but the crowning jewel is the monument at its heart. There, one of the four sisters erected a monument in honor of her mother and three sisters. The monument has four faces, each bearing a beautifully sculpted human likeness of "Faith," "Hope," "Charity" and "Liberty." Each side is a beautiful piece to behold, though somewhat weathered by time and age. The monument contains the genealogical history of the Smith family from 1641 until 1909 as well.

To me, one of the best stories is that of the sailors on the *Louis V. Place* schooner. Just up the path from the entrance on the right are eight tombstones, each bearing the name of a life lost in the *Louis V. Place* wreck. Of the eight stones, only four of the sailors are actually buried here. The tale is a sad one. On January 28, 1895, the schooner set sail from Baltimore, Maryland, with over one thousand tons of coal. It was an unusually cold winter, and nearly the entire East Coast was suddenly hit with a brutal storm on February 5. For two days, the men on the schooner battled the strong winds, ice and snow. The sails became frozen in their places, making it impossible to steer. Even the deck began to freeze. Frozen, sleep-deprived men found themselves

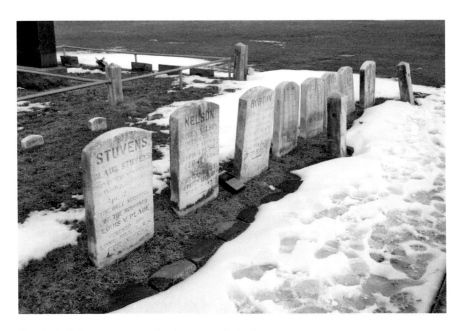

The *Louis V. Place* honorary sailors' graves at Lakeview Cemetery.

trapped on a floating iceberg, out of control. As a last-ditch effort, the captain decided to beach the ship, and they ran aground on a sandbar off the coast near the Lone Hill Life Saving Station.

Waves rocked the ship, and the men clung to the riggings while men on shore tried to mount a rescue. But every time they fired the Lyle gun, it was blown away by the winds or the men on board were unable to pull it in. Rescuers were finally forced to wait out the storm. In the end, only two men remained, severely frostbitten but alive. Of the two, Nelson died soon after of tetanus after having both legs amputated. Claus Stuvens survived and returned to the sea once more, unshaken by his ordeal.

Aside from the amazing story of human struggle, these eight small tombstones also hold a ghost story. According to an article in the *New York Times* and the *Brooklyn Eagle* back in 1895, local girls walking home from the old lace mill at sunset received quite a scare from these eight stones. When they were near the iron gate of the cemetery, two young women saw a figure in white rise from one of the *Louis V. Place* memorial tombstones. It climbed from a prone position to its knees before standing up. To their horror, they noticed that though the figure was all in white and had arms and legs, it was headless. A keening, moaning sound issued that added to their terror as the specter supposedly wandered over to a nearby tree and begin waving its

arms. Could it have been the spirit of a sailor still attempting to signal for help from the frozen riggings of the schooner?

Whether you like Lakeview Cemetery for the ghost stories, the beautiful statues or the wealth of local history contained within, it is always a pleasant place to take a walk. The old lace mill is gone, and the view from within is different now, but you can still feel the echo of a Patchogue long past in the silence around you.

Nixon's Dog

It wouldn't be fair not to include a cemetery for our furry friends. The Bide-a-Wee Association Pet Cemetery Memorial Park in Wantagh isn't odd because it's a pet cemetery but rather because of a particular dog interred there. Checkers was a spotted cocker spaniel that saved the political life of someone who would rise to be president of the United States. After he became a U.S. senator, Richard Nixon's wife mentioned their daughters wanted a dog. A man from Texas sent them the pooch as a gift. At the time, Nixon was under scrutiny over a political fund and receiving gifts. In retaliation, he appeared on TV explaining the situation. During the speech, he proclaimed, "The kids, like all kids, love the dog, and I just want to say this right now, that regardless what they say about it, we're going to keep it."

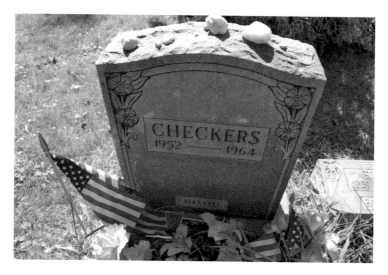

The grave site of Checkers, Nixon's dog.

This won the hearts of the American people, and Nixon went on to become vice president and president. Checkers is buried in Section 5, Row A, Site 38D. His tombstone says he lived from 1952 to 1964.

INDIAN FIELD BURIAL GROUND

This small field at the end of Talkhouse Lane is the final resting place for some of the Montaukett Indians. The Montauketts once ruled over the rest of the Long Island tribes, with the exception of those to the far west. That made their sachem (chief) a very prominent figure. The last sachems of the nineteenth century are buried here.

All but one of the Indians is buried sitting down, in a circle and marked only by a field stone, as their tradition dictates. The only marked tombstone is that of Stephen Talkhouse Pharaoh. Stephen was born in a traditional wigwam on the edge of property owned by whites. He was indentured to a white neighbor, as the story goes, for one dollar per pound. He weighed forty pounds at the time, so his mother was given forty dollars. Stephen eventually joined a whaling crew and sailed off to the Pacific. He visited California

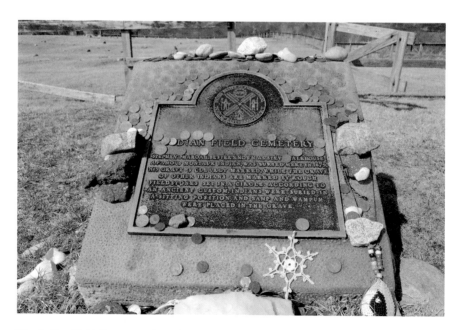

The Indian Field Cemetery where Stephen Talkhouse is buried.

during the gold rush and is said to have panned for gold. He then served in the Union army before finally settling in Montauk.

I use the word settle lightly because he would walk great distances. He would deliver letters and sell brushes to women between East Hampton and Montauk. He would frequently make the round trip in one day. It is said that he once walked from Montauk to Brooklyn in a single day. P.T. Barnum hired him as the "World's Greatest Walker." Part of the Paumanok hiking path follows the route Stephen would take. After the passing of Sachem King David Pharaoh, Stephen became sachem. One day, Stephen Talkhouse Pharaoh was found lying lifeless along his walking path. He was taken by tuberculosis. In the last year of his life, he converted to Christianity, hence the tombstone.

Union Cemetery

Like many other cemeteries, Union Cemetery in Middle Island looks unassuming and plain from the road, but wander a bit into its midst and you will find interesting lives memorialized within, as well as an intriguing story or two. Here you will find a melding of two different periods of history, ties to old Long Island families and maybe even a ghostly encounter.

The Middle Island Union Cemetery is about two miles east of the Village of Coram on Middle Country Road. The property was originally part of the Sweezey family farm. The Sweezeys are a well-known family even as far away as Patchogue, where the family ran a department store for many years. Their farm was turned into a public cemetery in the late 1800s. The current cemetery grounds include parts of two different cemeteries, the Old Burying Grounds of the Middleton Presbyterian Church and the grounds of the Union Cemetery Association of Middleton. Middleton is now known as Middle Island, just east of Coram.

The list of people buried in Union Cemetery looks like a page from Long Island history. Such well-known historic family names as the Bayles, Hawkinses and, of course, Sweezeys are plentiful, some even dating back to the 1700s. Some of the tombstones have interesting stonework and engravings. One in particular was the grave of a seaman engraved with a beautifully detailed anchor. In the far left corner there is a small grave of a child that seems to accumulate a new toy every time we visit.

As usual for us, our visits to Union would not be complete without a ghostly experience or two. The first concerns the aforementioned seaman's grave with

the anchor. It was nighttime, and I wanted to try to take an artistic night shot of the anchor. So I set up my tripod and took a quick flash picture with my camera to ensure I had it framed right before I switched to a longer shutter exposure. To my surprise, a strange fog came up on my photo that made me look up to see what was really there. About a foot behind the tombstone hovered a roughly egg-shaped cloudy mist. It hovered about a foot off the ground and was about five feet high and two feet wide. Baffled, I could only continue to shoot pictures as this odd mist moved through the tombstone, through me and then, as I turned to follow it, dissipated about three feet from me. I was able to capture four consecutive photos of the mist moving through before it cleared. We did some research into weather patterns and types of fog, but nothing matched the shape we encountered, and it still remains a mystery.

A few people have told me they believe a spirit named Alice still haunts the cemetery and that they have seen her. While I am skeptical, I did have a rather odd experience that seems to support this. A group of us were gathered at night sitting around the bench in the back. We were preparing our cameras and gear and just enjoying the peaceful night. I felt an odd sensation over my shoulder, as if someone were standing behind me looking over my shoulder. I could even feel something akin to body heat, as if whatever it was stood very close to me. I said nothing but started pulling my camera out of my bag in preparation of sneaking a shot behind me. As I was turning on the camera, one of the other girls raised hers and snapped a photo right over my shoulder. She then turned to me and said, "She was right behind you, but I didn't want to scare you." About six months later, I was at a gathering of paranormal enthusiasts and a woman approached me, asking if I had encountered Alice at Union Cemetery.

There is one last encounter at Union. The cemetery is very large, and we had broken up into three groups to do a photo shoot. John was with a group on the right side, and I was in the middle. Suddenly, across the cemetery on the left side, we heard my husband's voice call out. The left-most group then exclaimed over the radio in shock. They had seen the silhouette of my husband standing by a tree where the voice had come from, and it disappeared in front of their eyes. It was simply impossible for him to have been on the complete opposite side of the grounds from where he was with his group, and it left all of us scratching our heads.

We have had peaceful afternoons at Union Cemetery wandering amongst the tombstones reading the names or even sitting quietly under a tree. With a historic church in the next lot over, and so many Long Island families buried here, you can feel a connection to the Middle Island of past years and imagine what it may have been like.

ABOUT THE AUTHORS

John Leita started the "Long Island Oddities" blog in 2003. Through this blog, he shares his love of Long Island history and folklore. His writings on this subject were also published in the *Long Island Pulse* magazine. John has a passion for taking pictures of historic abandoned places and ruins. Realizing some of these places may not be around much longer, he began taking video and collecting historic photos of them. This led him to produce five documentaries to accompany his blog. His newest documentary, *Scary Long Island*, investigates the most reputedly haunted locations of Long Island. After performing many hours of research, he started lecturing at libraries, historical societies and schools. His lectures are always well attended and often receive praise from the attendees. In 2008, he started another blog called "Long Island Ruins," which interprets local history through abandoned and reused structures. His plans for the future include further sharing his love for what makes Long Island a unique place.

Laura Leita has a long-held interest in anything paranormal and has been reading up on the subject for most of her life. She co-runs "Long Island Oddities" with her husband and thoroughly enjoys exploring the island's most interesting and haunted places. She co-runs LIOPS, a local paranormal society. She has given presentations and taught classes on Long Island history and folklore at many locations and has had her photos and poetry featured in a gallery at the Oceanside Library. Her photographs have also been utilized by newspapers, as well as the *Long Island Pulse*.

Visit us at
www.historypress.net
...
This title is also available as an e-book